The Beauty of
MANAWATU
& WHANGANUI

Photographs by Graeme Matthews

Published by Photo Image
Blenheim, New Zealand
Phone/Fax: +64 3 570 5655
Email: g.matthews@clear.net.nz
www.graememmatthews.co.nz

Thanks to Garry O'Neill,
Chloe Winstanley and Gary Hayman.

ISBN 978-0-9876554-7-9

Printed in China 2015
Designed by Go Ahead Graphics, Christchurch
Photographs copyright © Graeme Matthews
Text copyright © Graeme Matthews

NORTH ISLAND

SOUTH ISLAND

N

W E

S

Mount Taranaki

43

47

48

Tongariro National Park

Whanganui National Park

Raetihi

Ohakune

49

Waiouru

Pipiriki

1

Taihape

Whanganui River

4

Mangaweka

Rangitikei River

Rua Ra

Whanganui

3

Hunterville

1

54

Marton

1

Bulls

Feilding

Sanson

3

Ashhurst

Palmerston North

3

Woodvil

Foxton

Manawatu River

1

Shannon

Levin

57

Tararua Ranges

2

The Beauty of
MANAWATU
& WHANGANUI

Situated along the south western coast of the North Island and stretching from Whanganui to Levin, the Manawatu-Whanganui region prior to colonisation was characterised by native bush and swampland. The rivers and lagoons had once been a valuable food source for early Māori settlers, and the larger tribes settled along the Whanganui River, with the sandy coastline providing access between other Māori settlements.

From 1831, early traders visited Whanganui following the negotiated purchase of 40,000 acres from Māori tribes. The purchase was problematic, however, with many Māori angered by the arrival of Pākeha onto land that they still claimed, and it was 8 years before any official agreements were reached between the colonials and local tribes. Land was cleared for pastures and Whanganui grew rapidly after this time, and the town became a major military centre during the New Zealand Wars of the 1860s. Further south, European settlement commenced along the coast and extended inland from the Rangitāne land, on which Palmerston North and Feilding were established.

Whanganui and Palmerston North (in addition to neigbouring towns Levin, Foxton, Ashhurst, Bulls and Taihape), have now become thriving areas, each with their own character. With their settlers having cleared the forest and farmed the land, the towns now have museums and features that each reflect their own rich unique history; worth mentioning are the *Whanganui Regional Museum* and *Te Manawa* in Palmerston North, which hold a fantastic collection showing our Māori heritage and local history.

Tertiary education in the region is centred in Palmerston North and the city is often referred to as 'The Student City'. With students from over 60 countries it boasts a cosmopolitan and vibrant community, and *Massey University*, the main provider, is the nation's largest institution for life sciences, agriculture, horticulture and veterinary teaching/research. *Te Wananga o Aotearoa*, which focuses on 'whanau transformation through education,' offers a

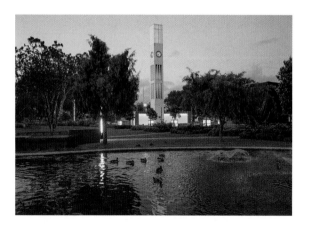

range of qualifications and includes the teaching of Te Reo Māori, Māori knowledge, social work, computing, arts education, and sport and fitness. The *International Pacific College*, also located in Palmerston North, is one of the first private tertiary institutes to be established in New Zealand, and has earned a reputation for delivering a global vision for education, with their programmes focusing on international business, relations, and languages.

Te Awa o Whanganui (Whanganui River) has attracted visitors from the beginning of its settlement, being the longest navigable waterway in New Zealand, and the region is also home to the Rangitikei River, a great destination for jetboating, white water rafting, kayaking, and fishing.

The region provides for advancement in education, farming, and the arts. For art lovers the *Sarjeant Gallery* collection houses much by way of New Zealand art history, and keen ruby players and supporters alike may want to visit

the Rugby Museum in the *Te Manawa* building. Foxton's working windmill, *De Molen* (meaning The Mill) is an exact replica of a Dutch windmill, and behind it the *Flax Museum* has a working flax stripping machine.

Down the road, *MAVtech* is an antique cinema, photo and gramophone museum, which draws thousands of visitors every year, and the Manawatu River Estuary conservation area closeby is a popular spot for watching migratory birds like godwits, wrybills and spoonbills that inhabit the flats.

Victoria Esplanade is 19 hectares of land along the Manawatu River, and offers a wealth of recreational and leisurely activities for the whole family, including train rides through native bush, expansive playgrounds for young ones, and various sporting fields. The Tararua Ranges near Palmerston North have many treks and cycle tracks through beautiful native forest, and a visit to the Manawatu Gorge is a marvellous opportunity to catch a glimpse of some truly breathtaking New Zealand scenery.

Feilding thrives with its nationally recognised *Farmers' Market*, the largest in New Zealand, and with up to 100 stalls the *River Traders and Whanganui Farmers' Market* is a hive of activity every Saturday morning. On Sundays the same can be said for *Foxton's Dutch Market* on State Highway 1.

As evidenced the hugely diverse region has plenty to offer, and wherever you go there is much to explore and be drawn in by—no matter your age or your interests.

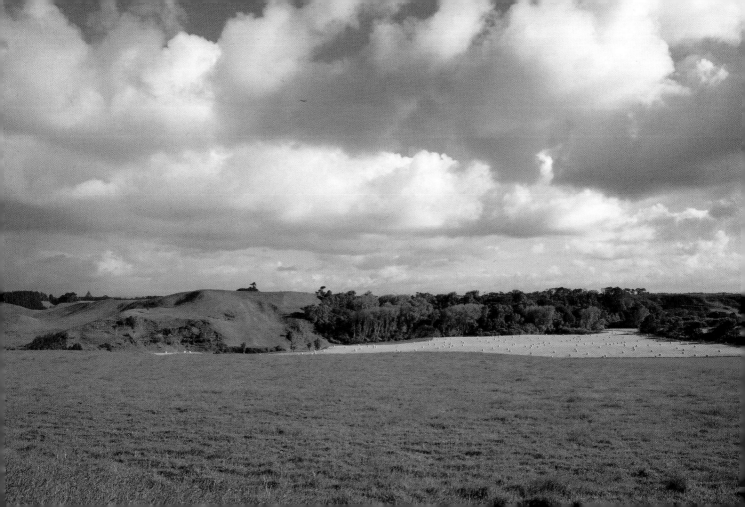

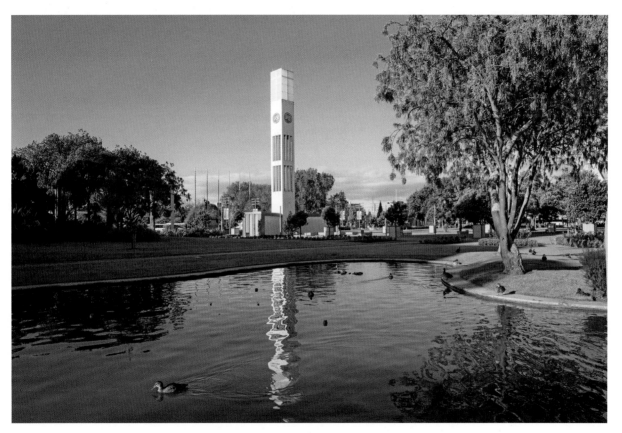

Above: The clock tower in the Square, Palmerston North.
Opposite: Green pastures under a bright summer sky.

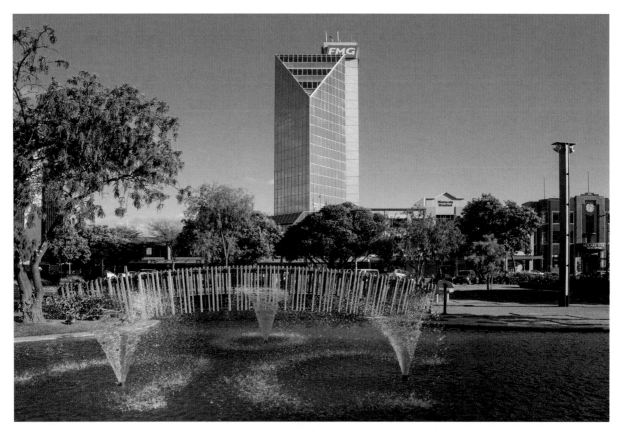

Fountains enliven the Square, and in the distance is FMG House, Palmerston North's highest building.

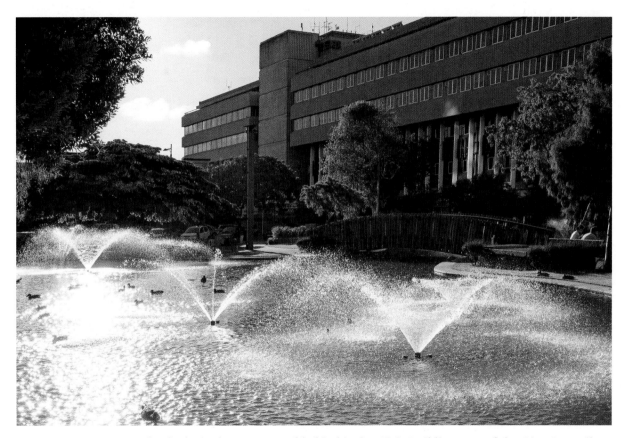

Fountains entertain the ducks in the Square, and behind is the Civic Building, seat of the City Council.

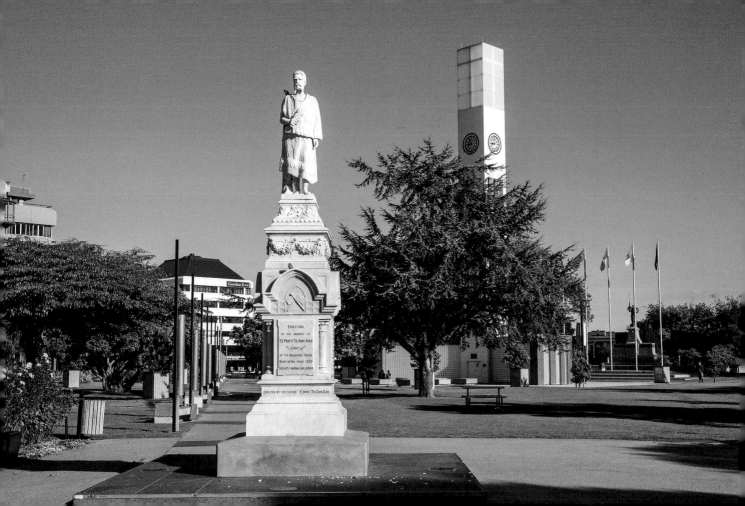

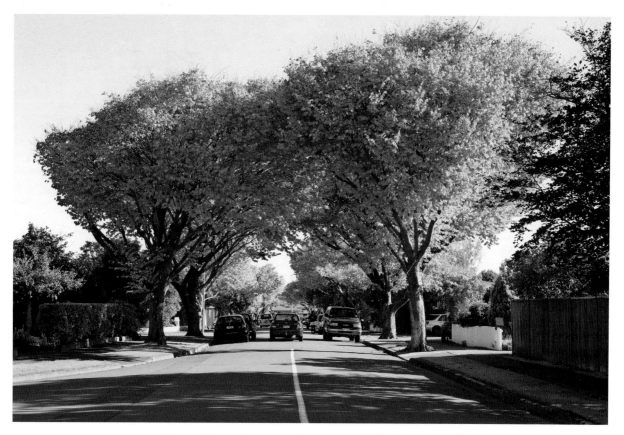

Above: Ake Ake Avenue in autumn, Palmerston North.
Opposite: The statue of Te Peeti Te Awe Awe, chief of the Rangitāne tribe in the early 1800s.

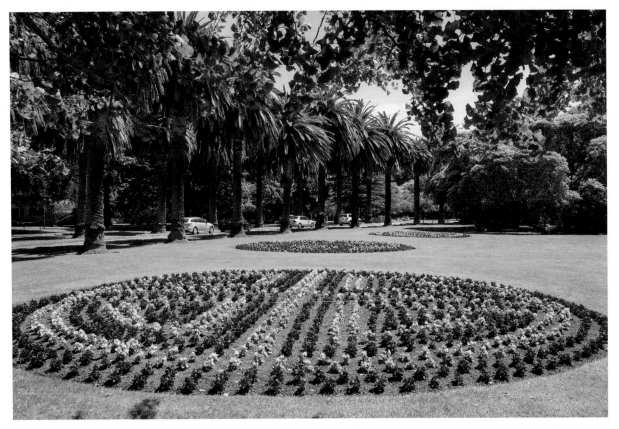

Above: The Victoria Esplanade Gardens in Palmerston North, opened in 1897 to commemorate the 60th jubilee of Queen Victoria's reign. Opposite: The Phoenix palm trees in the Victoria Esplanade Gardens.

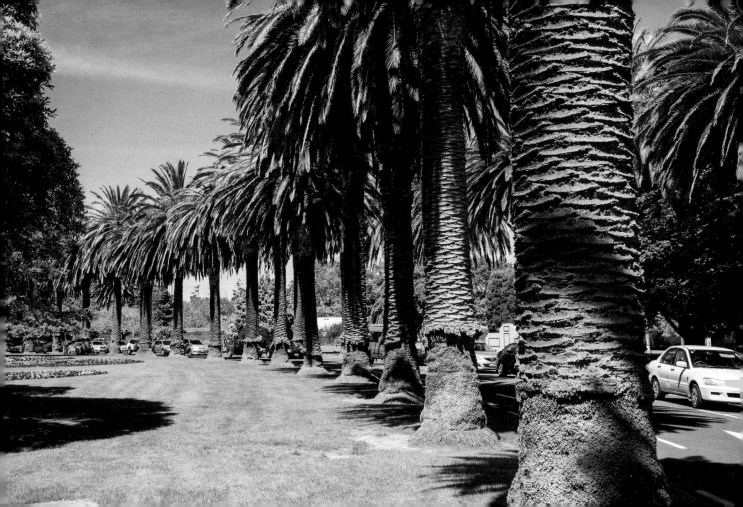

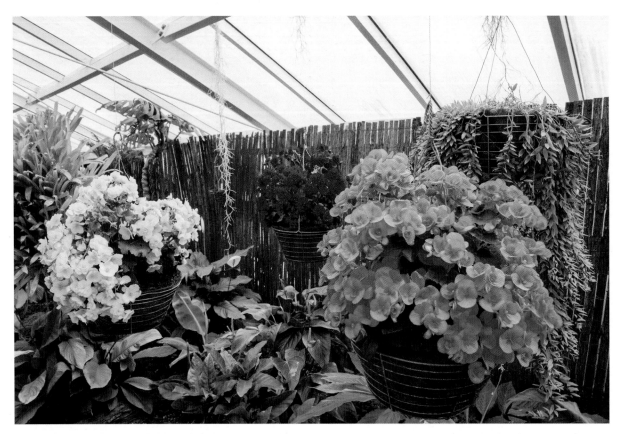

The striking Begonias of the Peter Black Conservatory, Victoria Esplanade Gardens.

The Manawatu River flows close to Palmerston North.

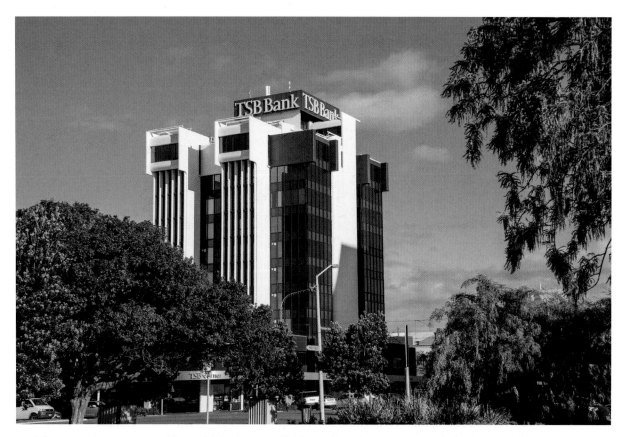

The towering 11-storey Taranaki Savings Bank Tower in Palmerston North, built in modernism style.

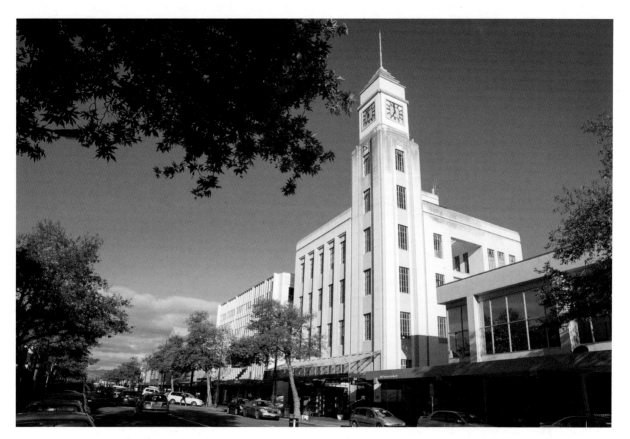

The elegant Art Deco Ansett Tower in Palmerston North, built in 1938.

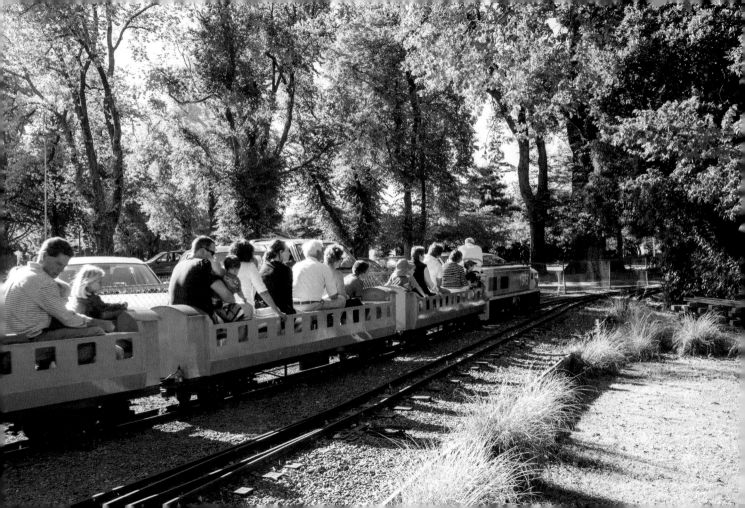

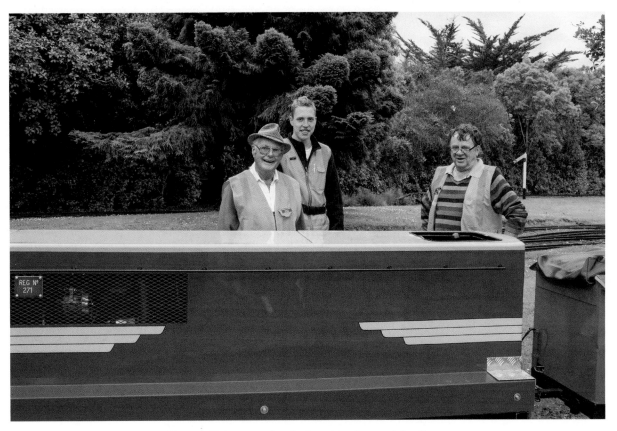

Above: Volunteers lend a hand at the model railway.
Opposite: Joyriders of all ages take a ride on the model railway in Victoria Esplanade Gardens.

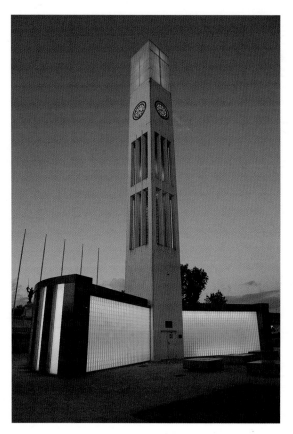

In the evening, Palmerston North's clock tower changes colour dramatically.

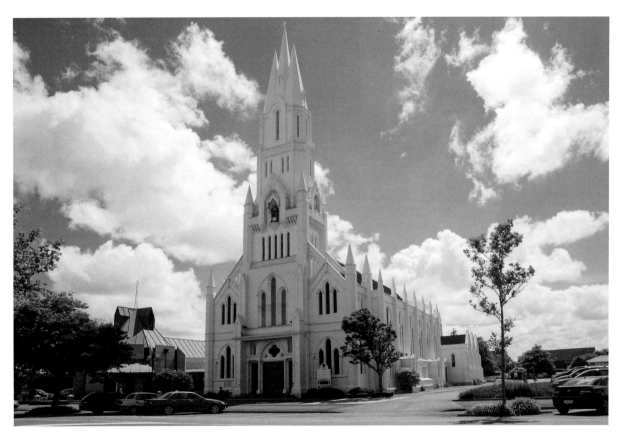

'The Cathedral of the Holy Spirit' in Palmerston North – one of the finest
English-style gothic churches in New Zealand.

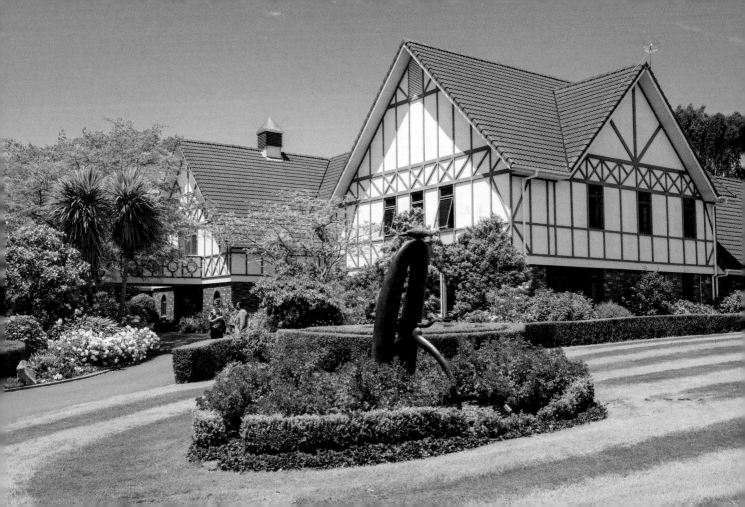

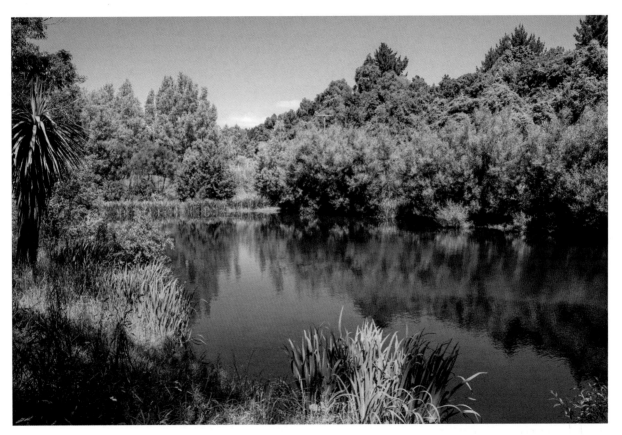

Above: One of the small lakes of the Tutukiwi Reserve in Aokautere.
Opposite: Palmerston North's International Pacific College.

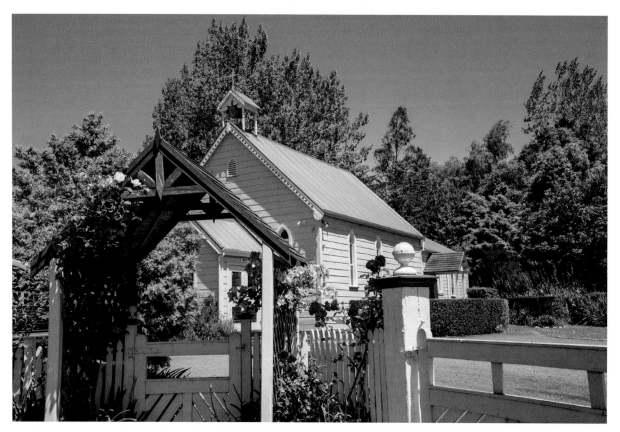

A quaint view of the Aokautere Community Church.

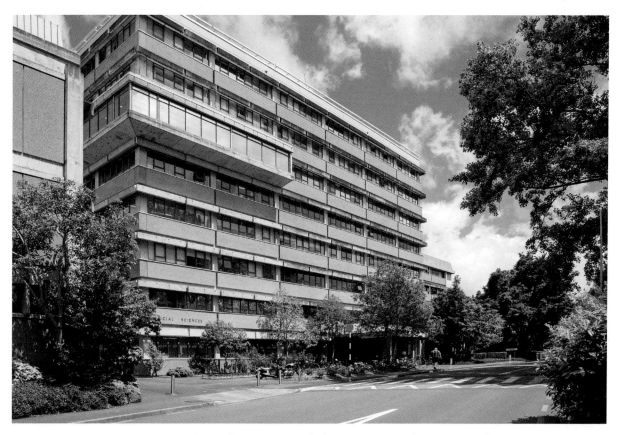

Massey University, Palmerston North, has approximately 35,000 students, 17,000 of whom are extramural or distance learning students.

Above: Students on campus.
Opposite: The greenery of the Massey campus.

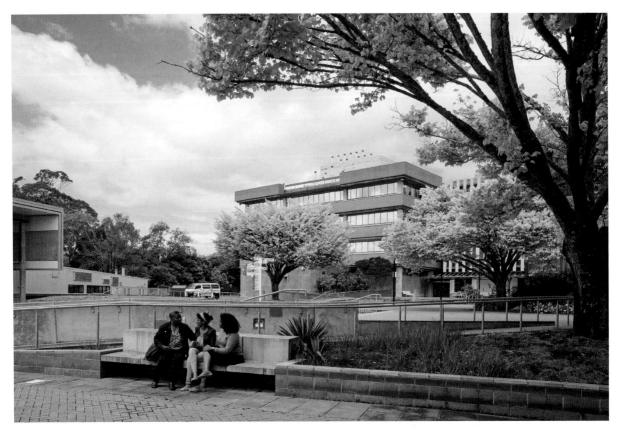

Above: The Massey University campus – a friendly and engaging place.
Opposite: The entrance to Massey University, bordered by trees.

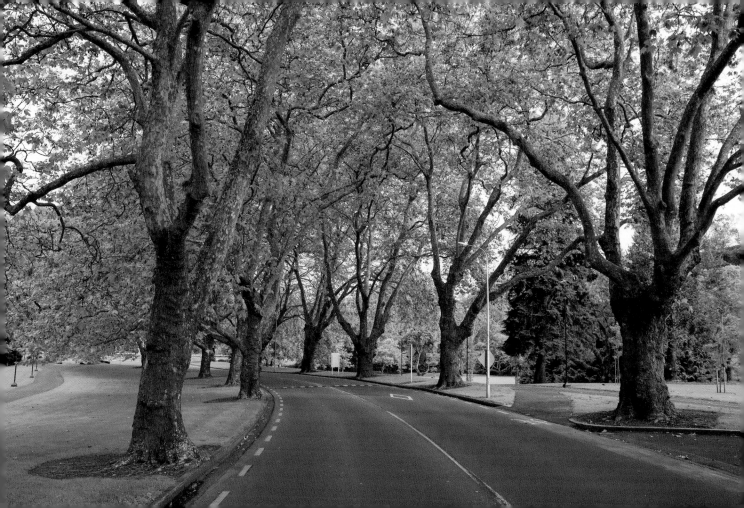

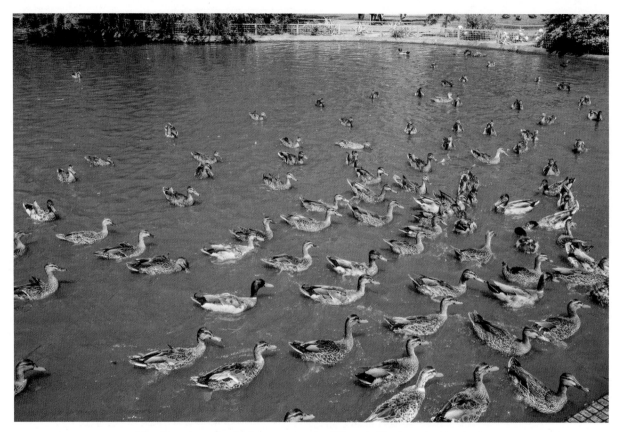

'Getting your ducks in a row' – the Victoria Esplanade Gardens.

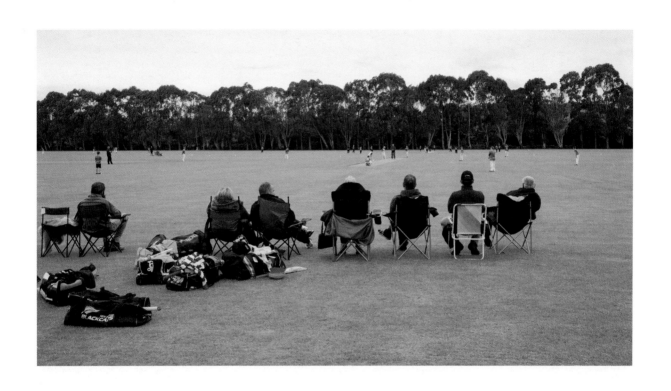

Parents watch pupils play Saturday morning cricket at Ongley Park.

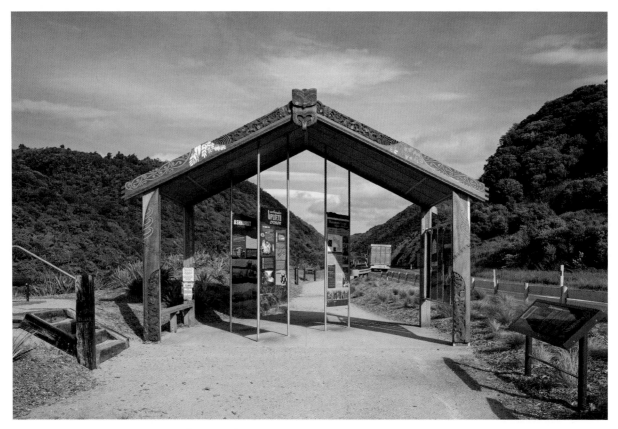

Above: The carved entranceway to the Manawatu Gorge Track.
Opposite: The 10km Manawatu Gorge Track offers some great scenic views.

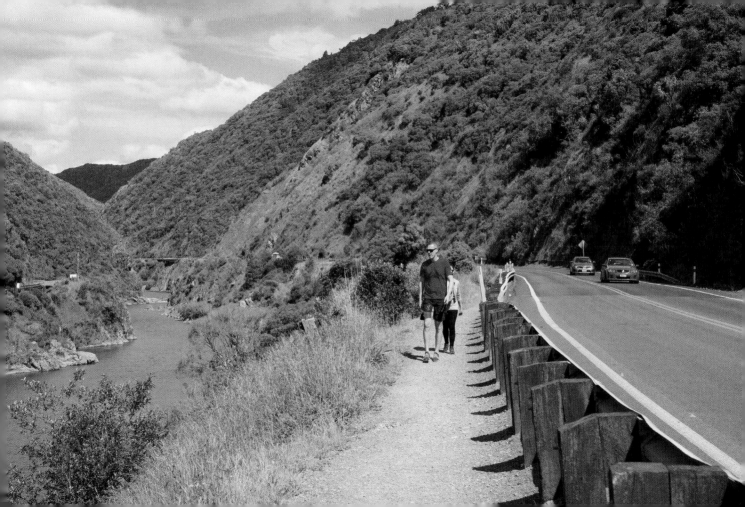

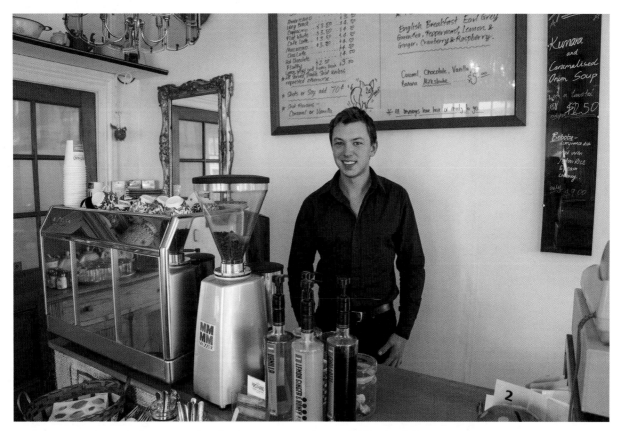

Above: Reinhardt, the manager of Woodville's 'Nibbley Pig Café'.
Opposite: Windmills atop Te Apiti Wind Farm.

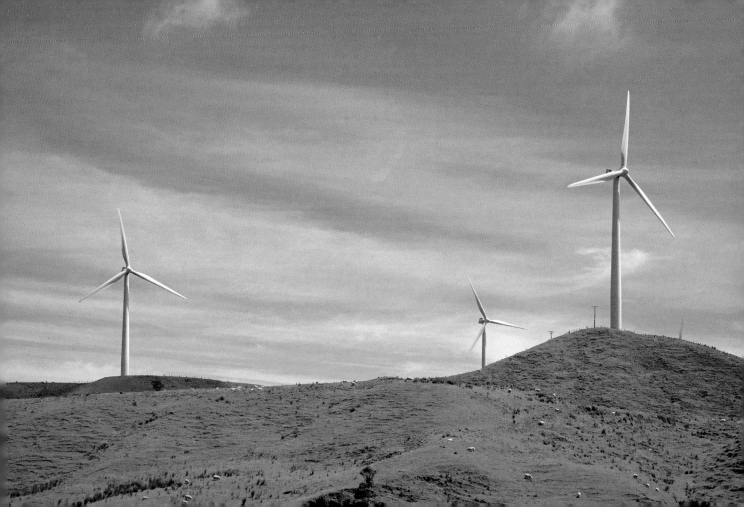

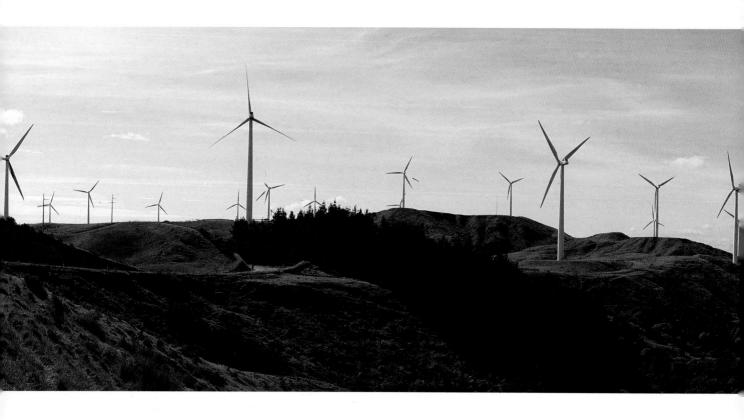

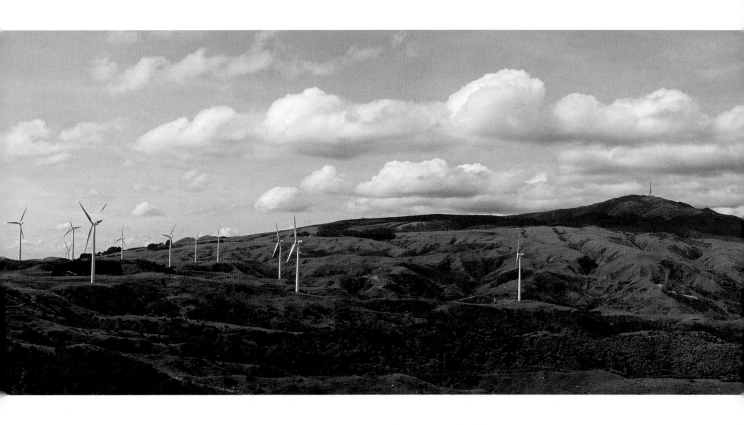

A panorama of Te Apiti Wind Farm windmills.

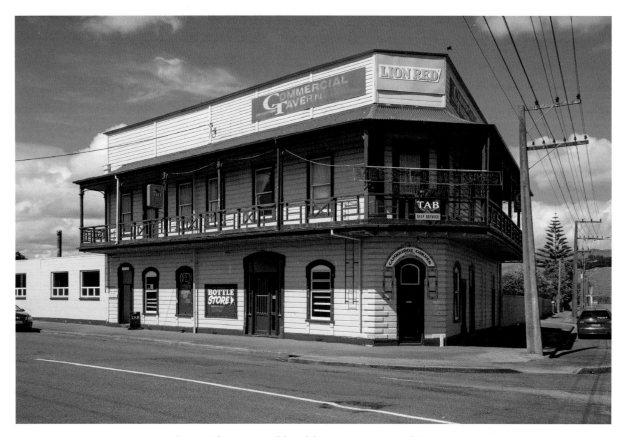

Above: The iconic old Ashhurst Commercial Tavern.
Opposite: Picturesque Pohangina is a river valley located at the foothills of the Ruahine Range.

Pohangina Valley's *Tiro Roa* is a beautiful nursery and garden.

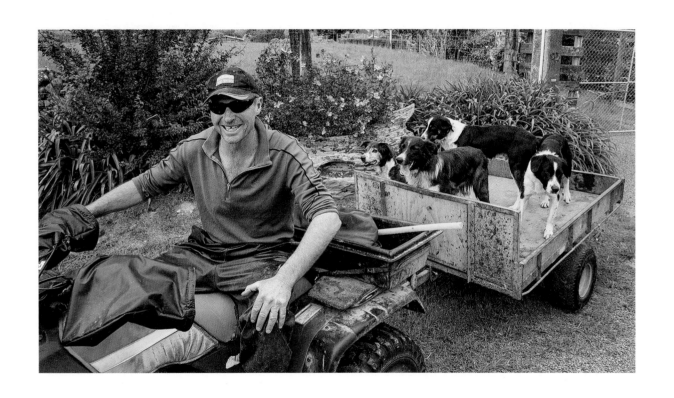

Farmer Steve and his companions heading out for a day on the farm.

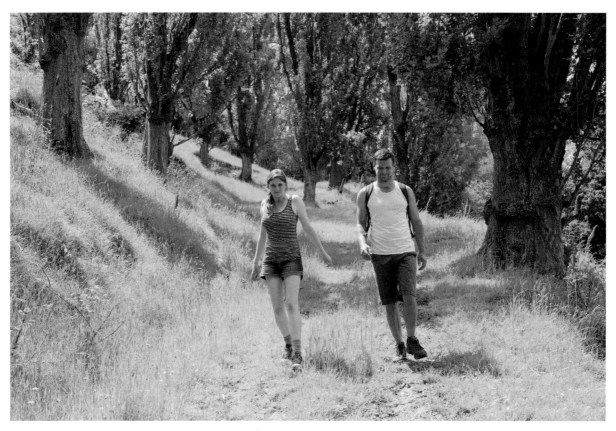

Above: Mel and Dave tramping along the Beehive Creek walkway.
Opposite: The Pohangina River.

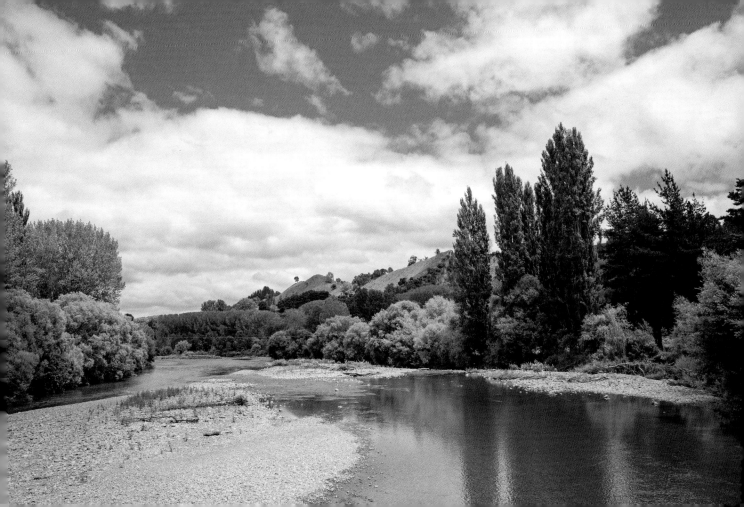

Above: Wayne setting out to deliver mail in Pohangina Valley.
Opposite: A novelty letter box on the road to Himatangi Beach.

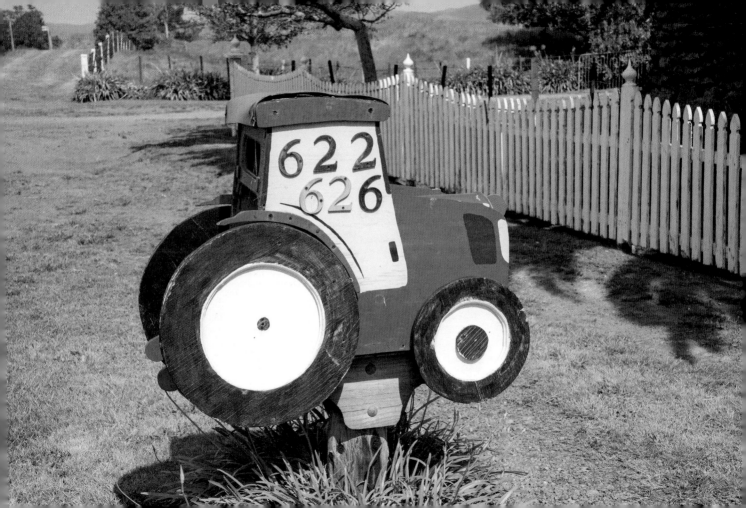

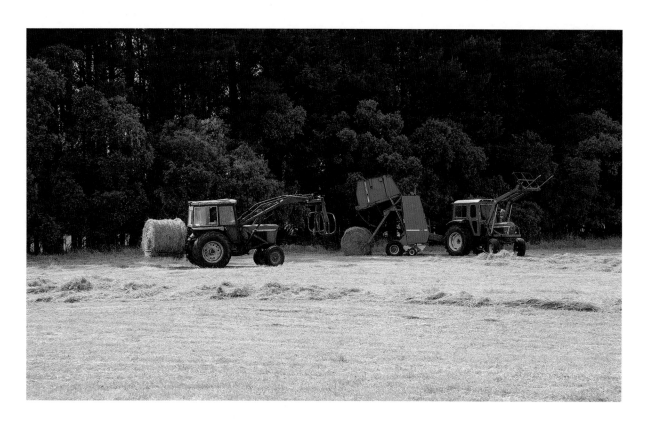

Bailing hay at the beginning of summer.

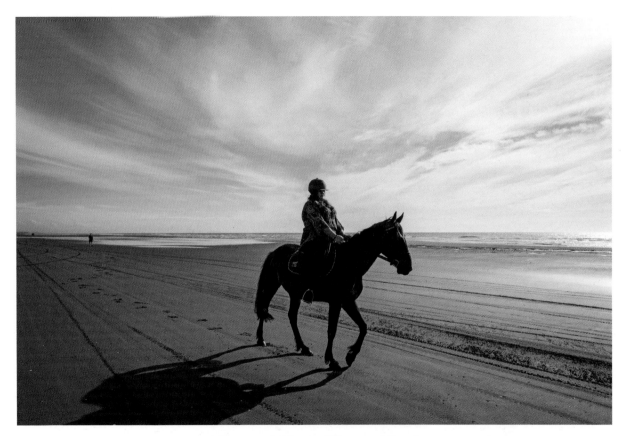

A horse and rider on Himatangi Beach.

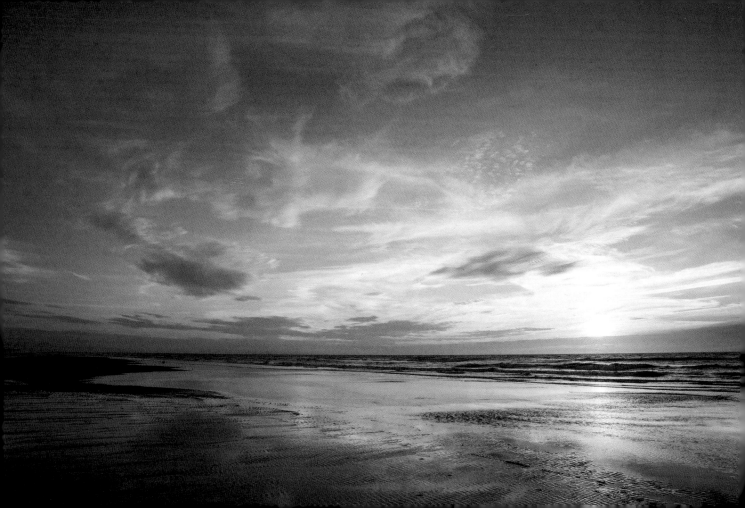

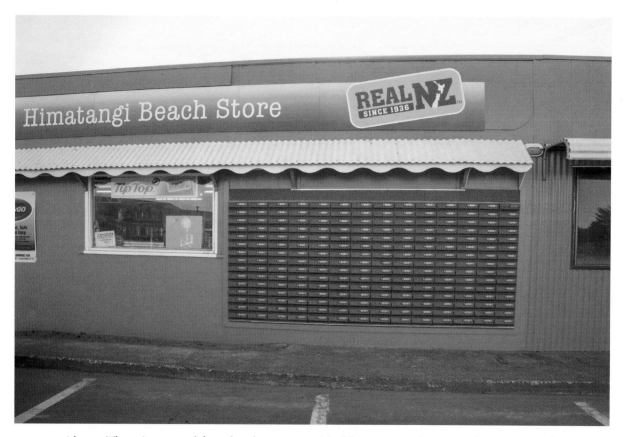

Above: There is no need for a local postman with this many postboxes – Himatangi Beach.
Opposite: Himatangi Beach at sunset.

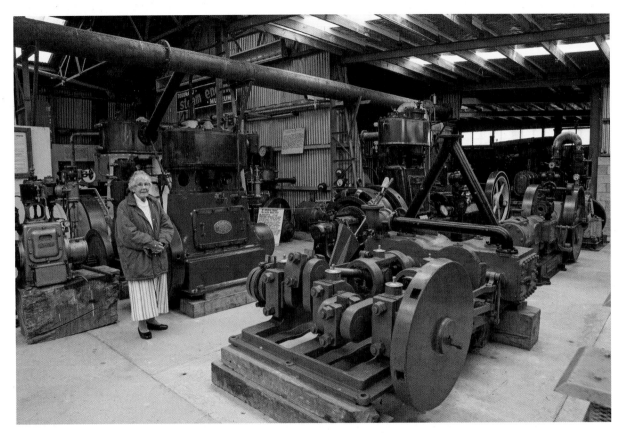

Above: Esma guides visitors to the interesting Tokomaru Steam Museum.
Opposite: Driftwood under a clearing sky on Waitarere Beach.

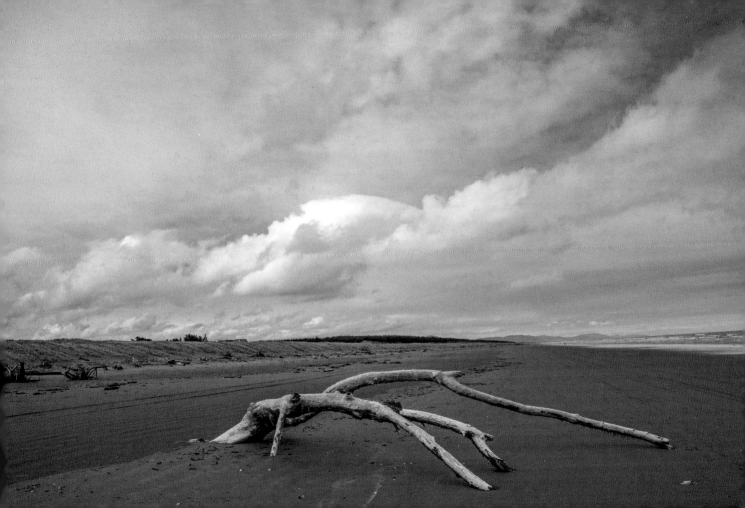

Inside Owlcatraz's owl enclosure in Shannon.

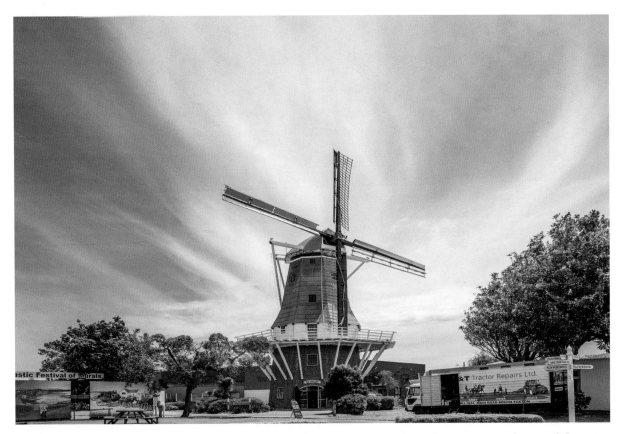

De Molen (the Mill) in Foxton. The working Dutch-style windmill produces a range of ground flour.

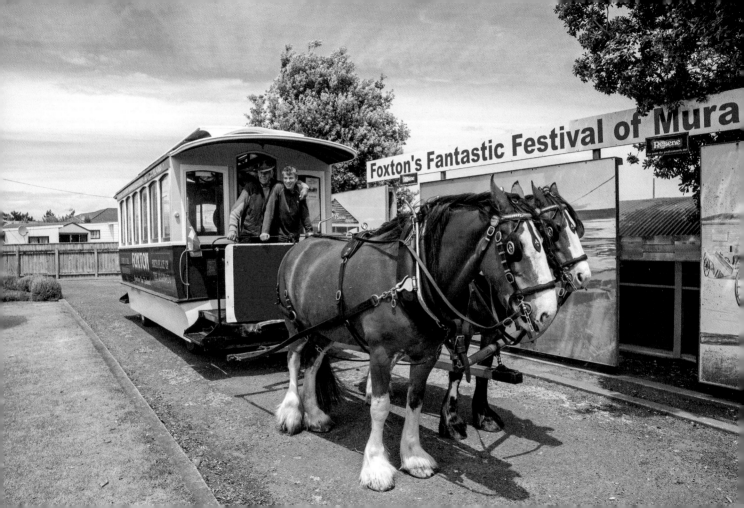

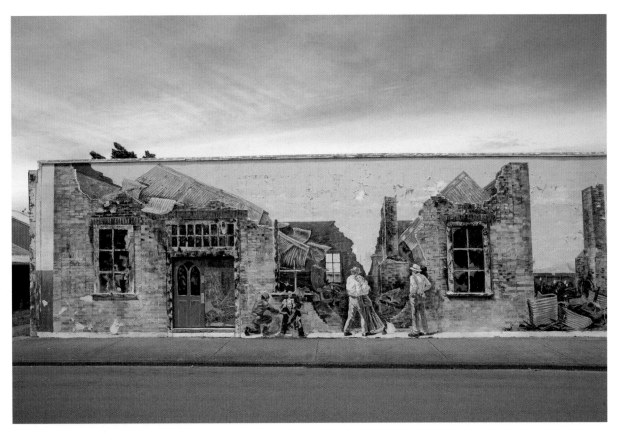

Above: One of Foxton's many breathtaking murals – all painted, aside from the door which is real.
Opposite: Volunteer drivers Jim and Jayden stand aboard the Foxton horse-drawn carriage.

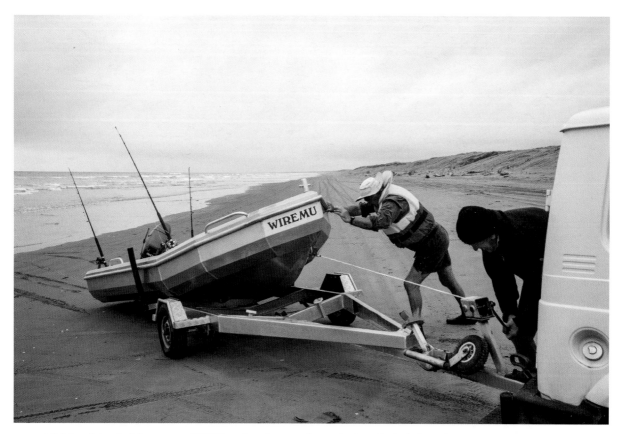

Fishing friends Murray and William hard at work retrieving their fishing boat on Foxton Beach.

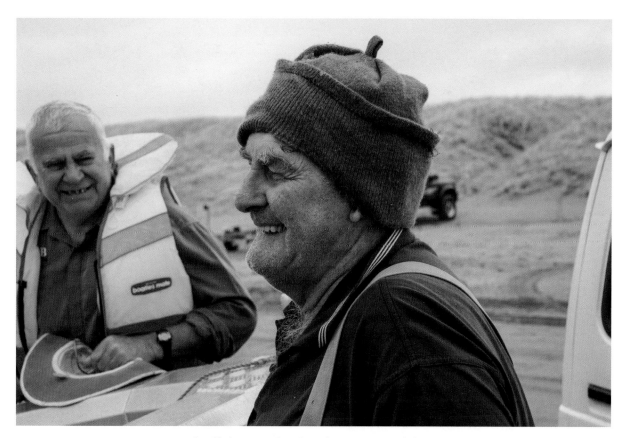

Murray and Bill share a joke after the morning's fishing excursion.

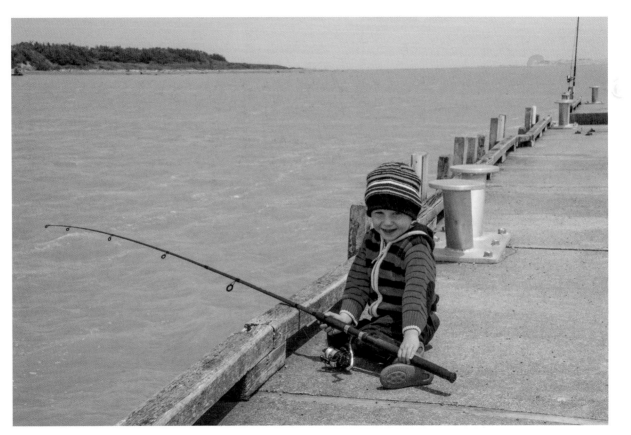

A young fisherman following in his father's footsteps, on the Foxton Beach wharf.

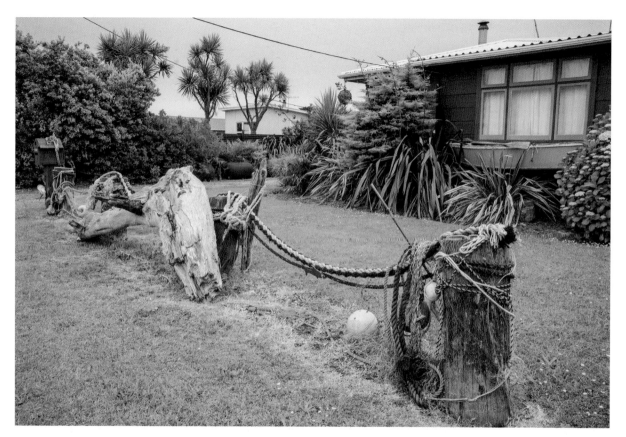

A Foxton Beach bach and its front fence – beach flotsam style.

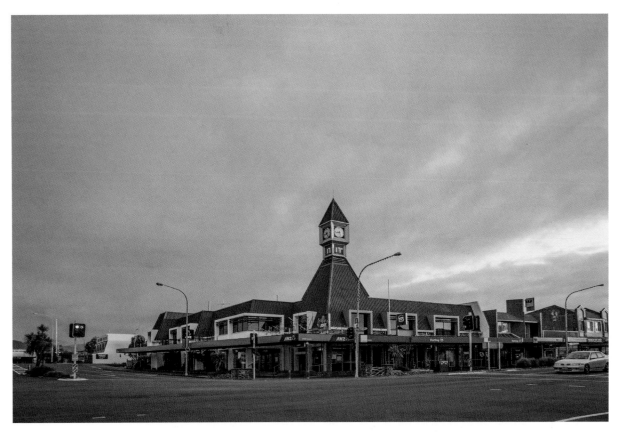

Above: The Post Office Clock Tower in the centre of Levin, at sunset.
Opposite: Lake Horowhenua and a few of its happy residents.

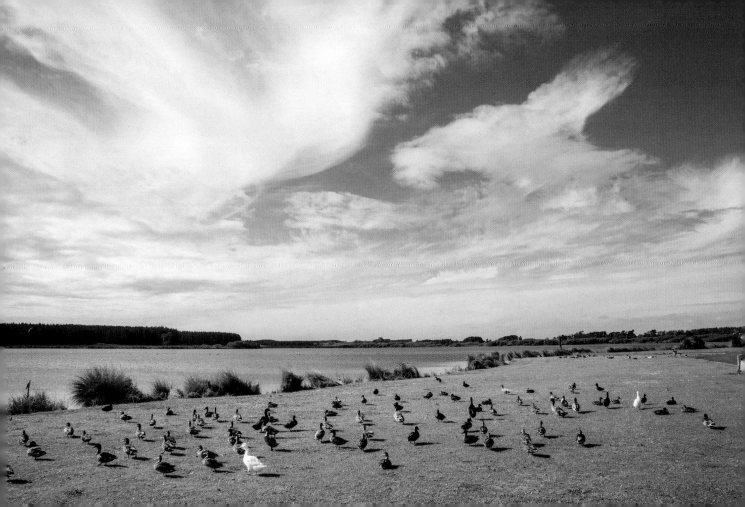

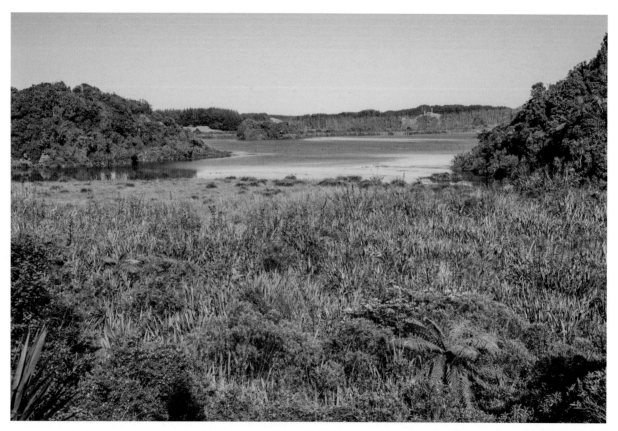

A lovely view of the secluded Lake Papaitonga, near Levin.

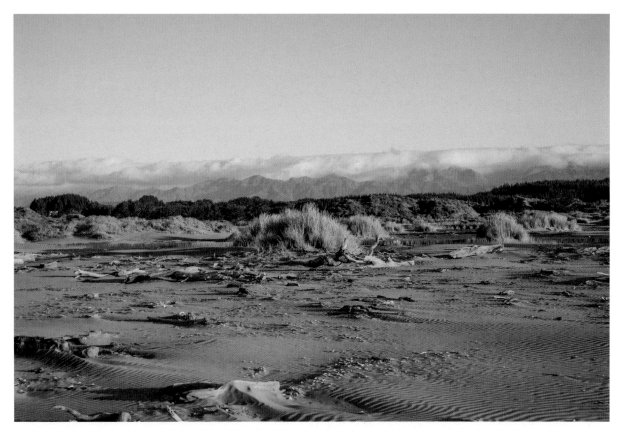

Sandy Hokio Beach – and in the distance, the clouds hover above the Tararua Ranges.

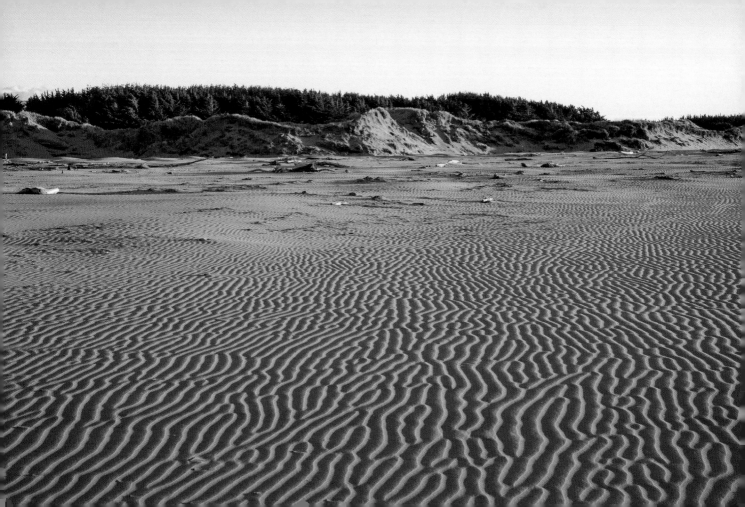

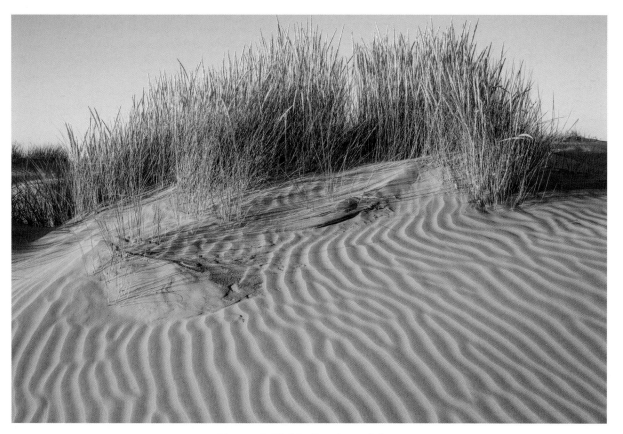

Above: A Hokio Beach sand dune.
Opposite: The wind blows picturesque ripples in the sand of Hokio Beach, near Levin.

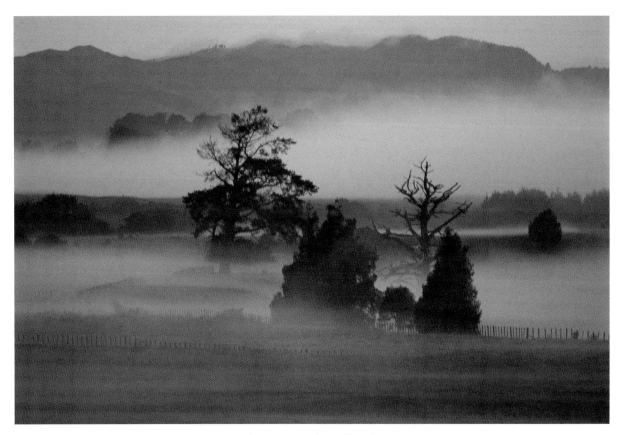

Morning mist hangs over the valley floor in winter.

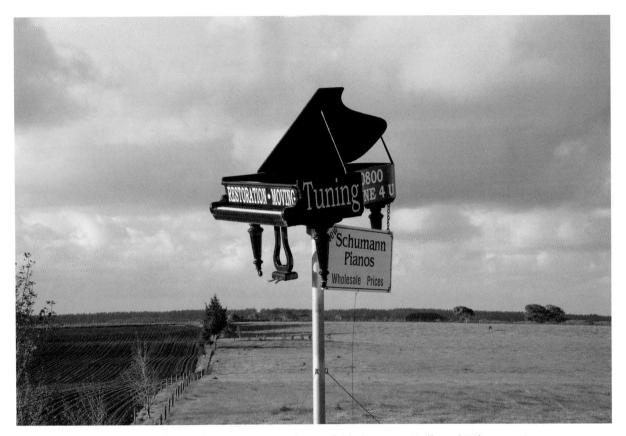

An eye-catching advertisement on the roadside between Bulls and Whanganui.

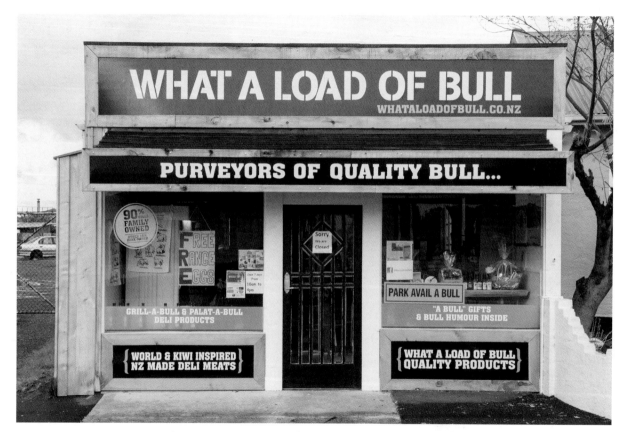

Above: An aptly named local novelty shop in Bulls.
Opposite: Emily gets ready to open one of the Bulls coffee shops.

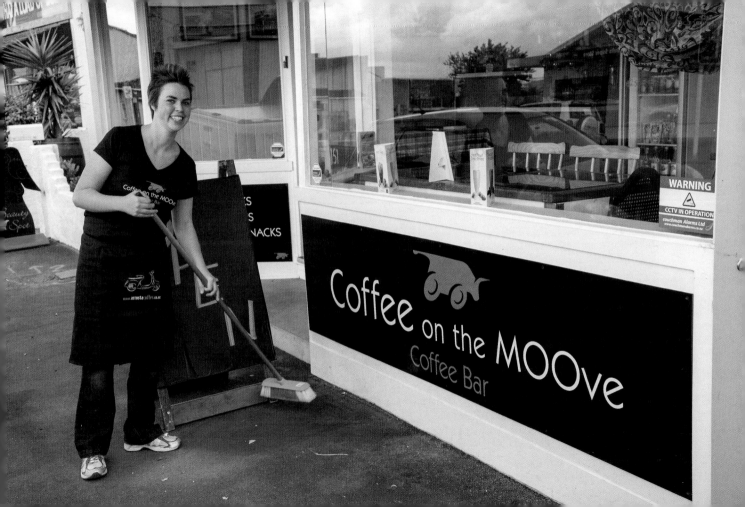

Dudding Lake, near Whanganui, a popular picnic spot and campground.

The Cameron Blockhouse – an historic building, built in 1868.
It was built by Cameron to protect his family from a possible attack during the Māori wars.

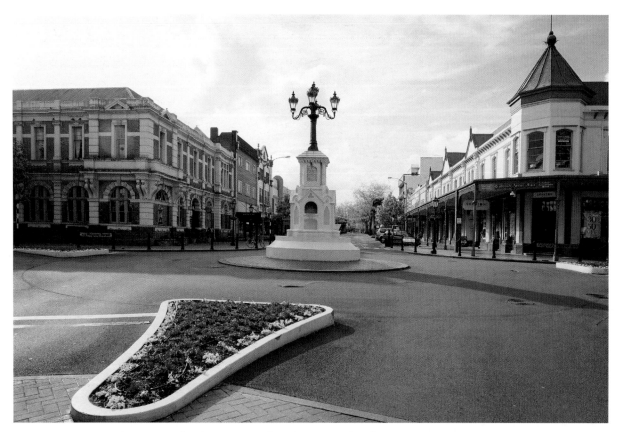

The centre of Whanganui still makes room for flowers – Victoria Avenue.

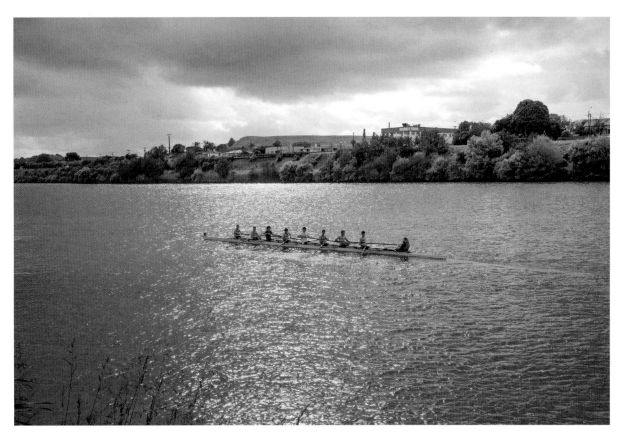

A rowing eight on the Whanganui River.

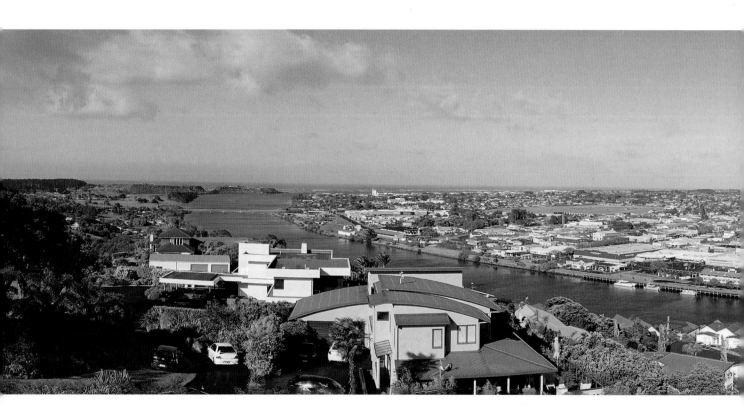

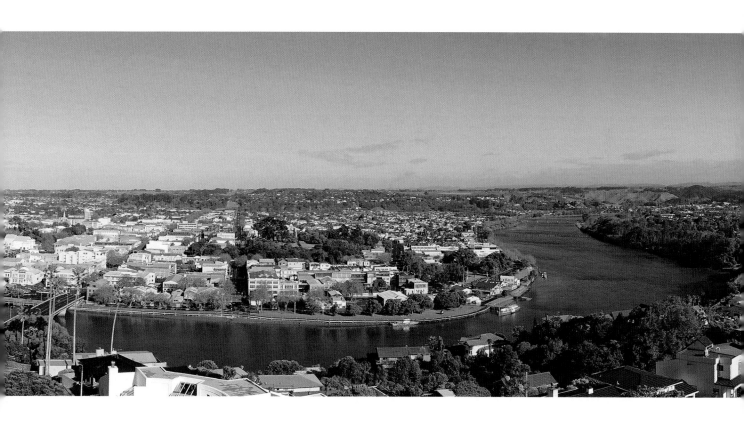

Whanganui – from the viewpoint atop Durie Hill.

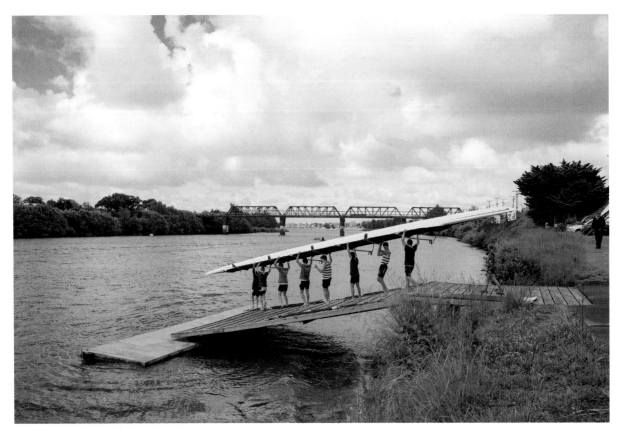

A rowing crew launches an eight-man rowing skiff during a regatta on the Whanganui River.

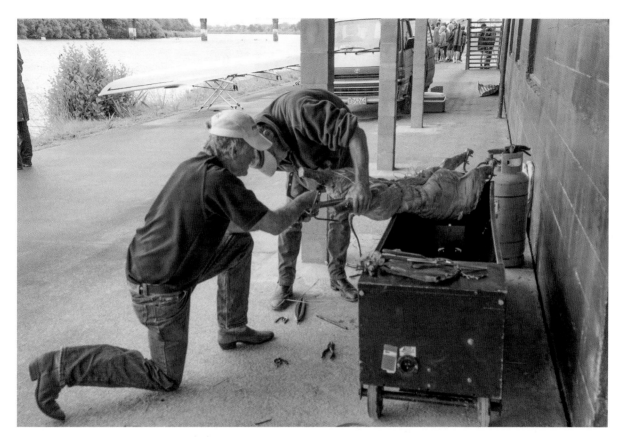

Preparing a sheep for the rowing regatta barbeque in Whanganui.

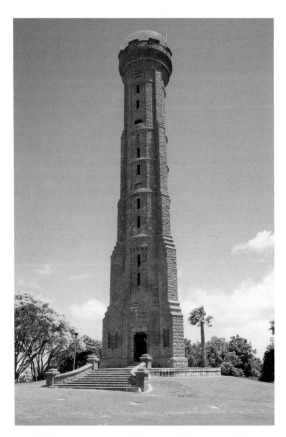

The war memorial tower at Durie Hill.

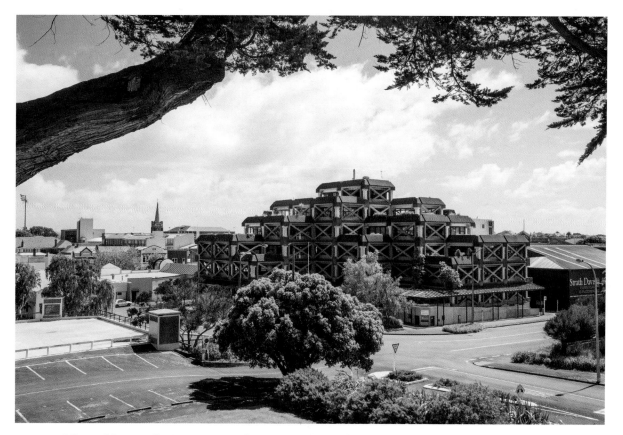

The architecturally interesting Whanganui School of Design (UCOL), established in 1987.

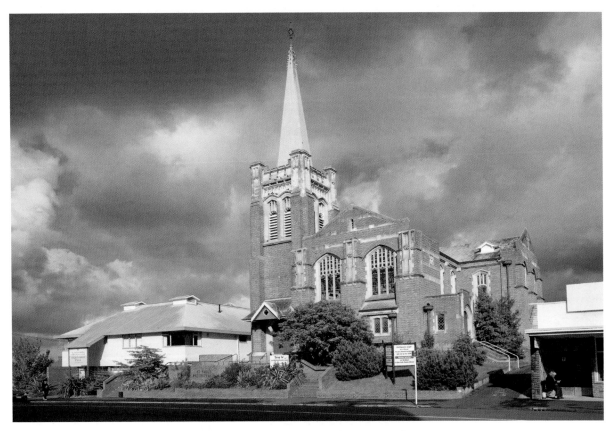

Above: St. Paul's Presbyterian Church in Whanganui.
Opposite: The Dublin Street Bridge built over the Whanganui River in 1914.

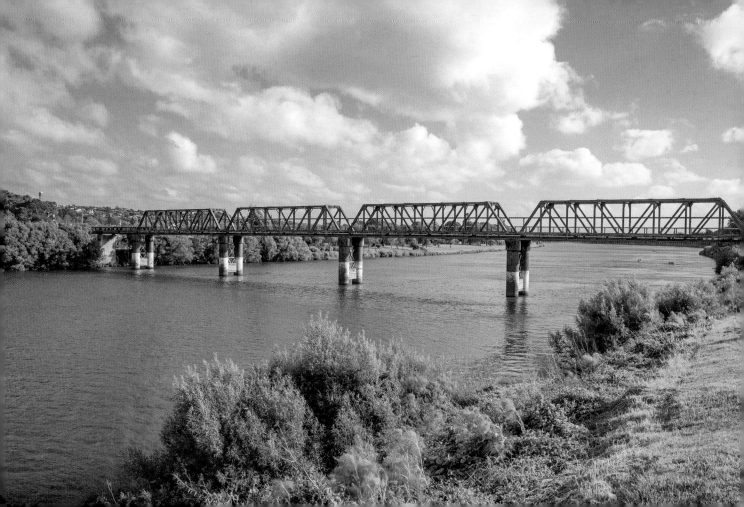

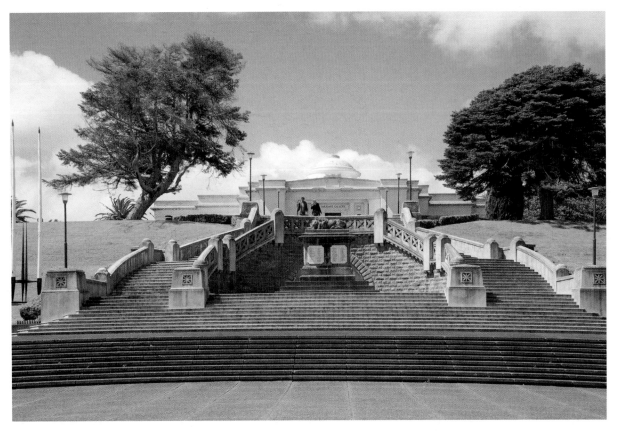

The suitably impressive entranceway to the Sarjeant Art Gallery.

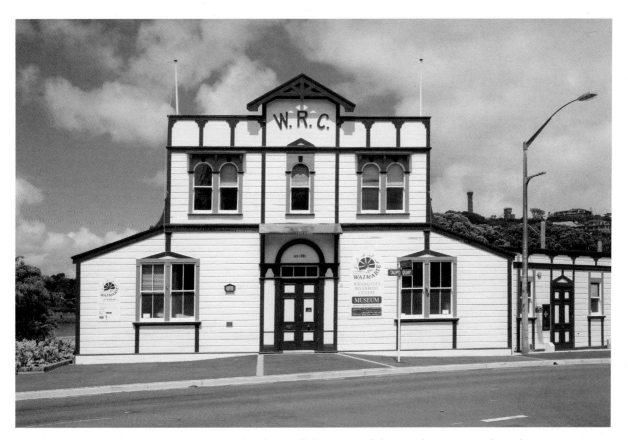

Whanganui Riverboat Centre Museum displays tell the story of the riverboat era on the Whanganui River.

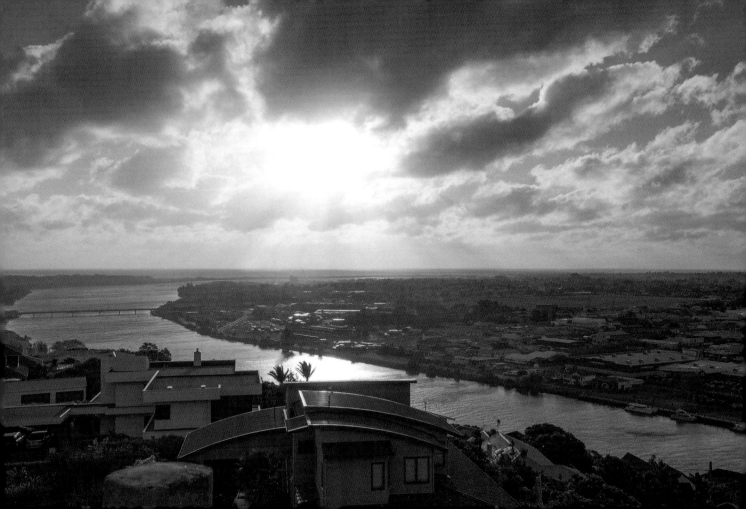

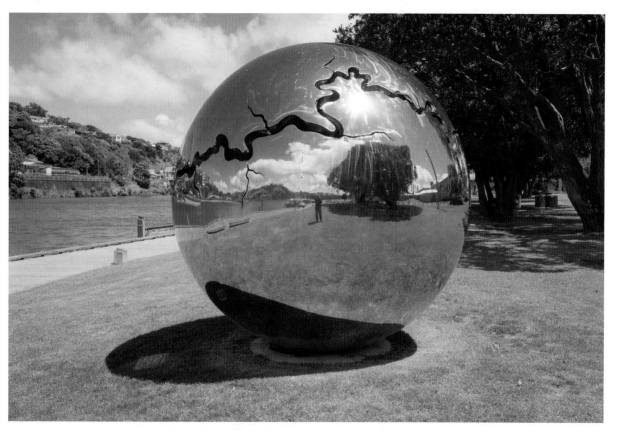

Above: A fissure representing the Whanganui River carved into a large polished stainless steel globe.
Opposite: The sun sets to the west over the city of Whanganui.

Above: Geraniums liven up the farm gate.
Opposite: Out on one of its excursions, the *Waimarie* paddle steamer cruises upstream.

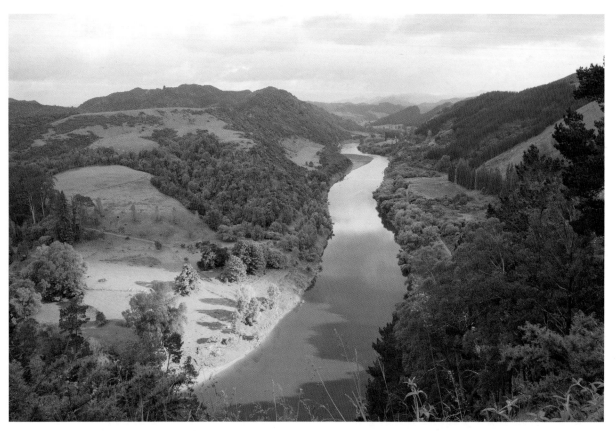

Above: The Whanganui River – as seen from the high viewpoint on Whanganui River Road.
Opposite: Morning sun lights up farmland along the Whanganui River.

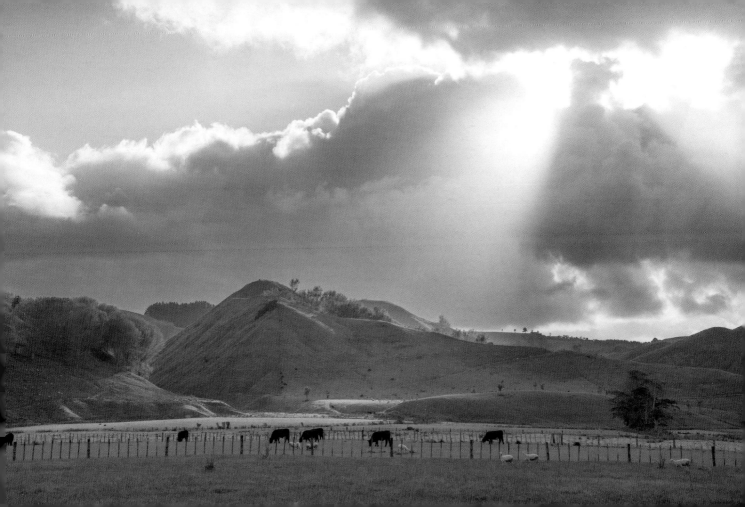

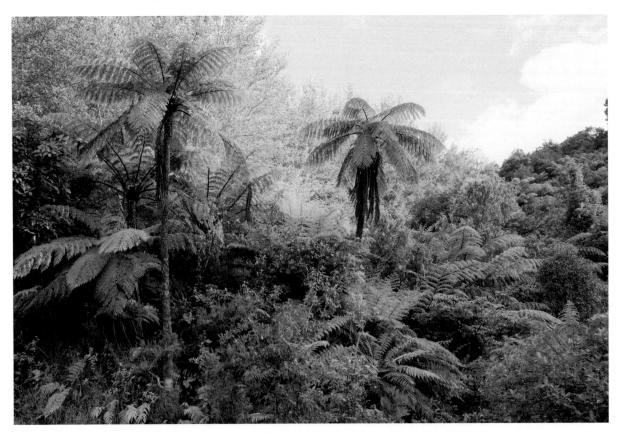

Tree ferns and native bush along the Whanganui River Road.

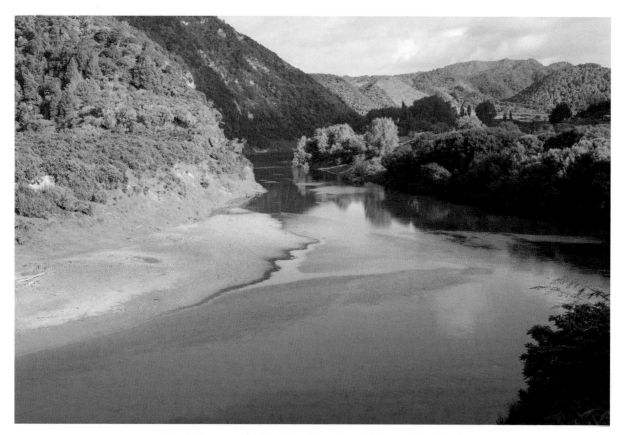

The Whanganui River flowing sluggishly at a low level.

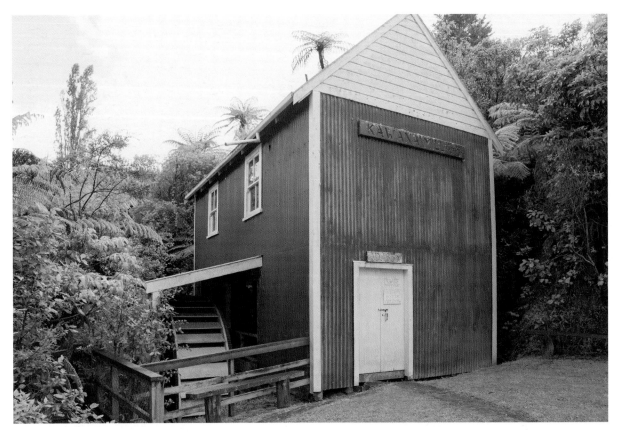

Above: Built in 1854, the Kawana Flour Mill sits on the banks of the Whanganui River.
Opposite: Located on a bend of the Whanganui River, the small settlement of Jeruselum and its church.

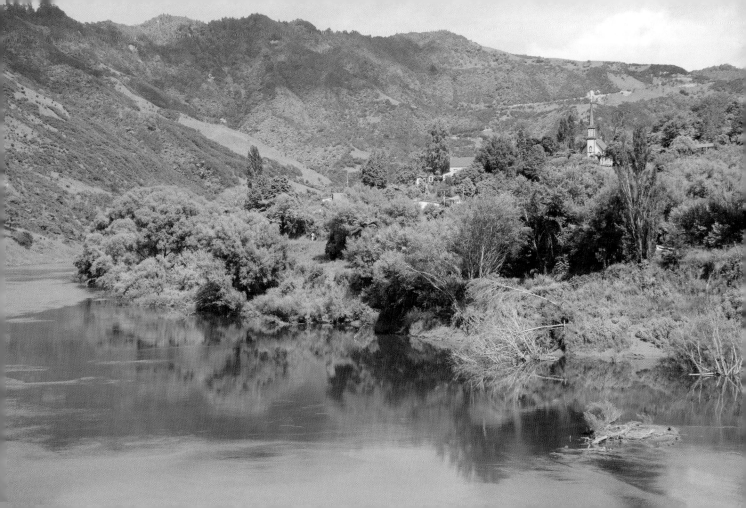

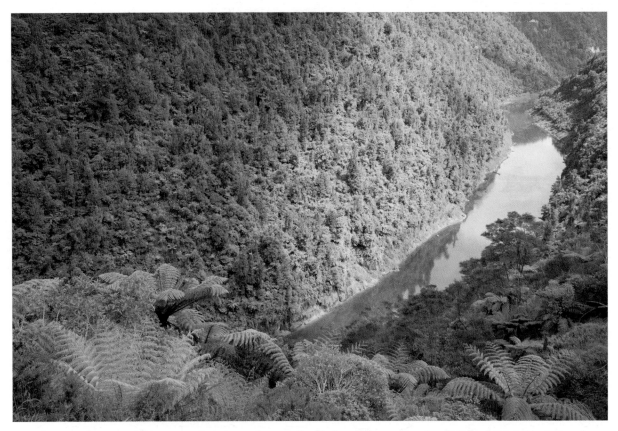

Above: Whanganui River running through a confined channel – as seen from Whanganui River Road.

Opposite: A hunter on horseback, gearing up to set off into the bush – Pipiriki.

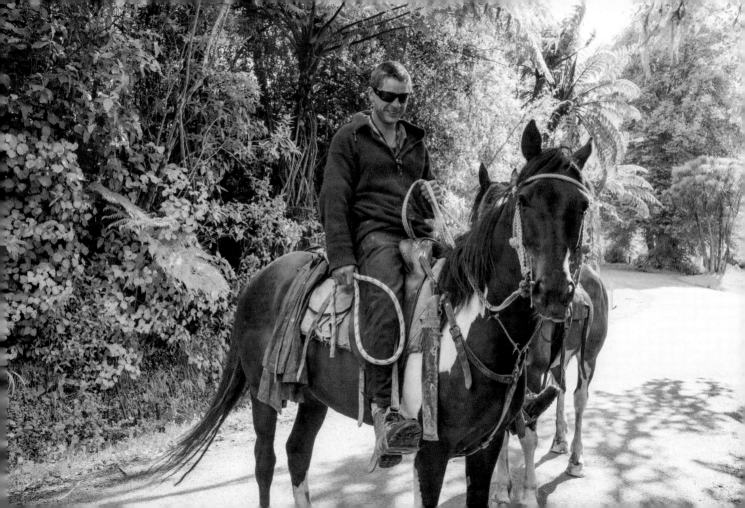

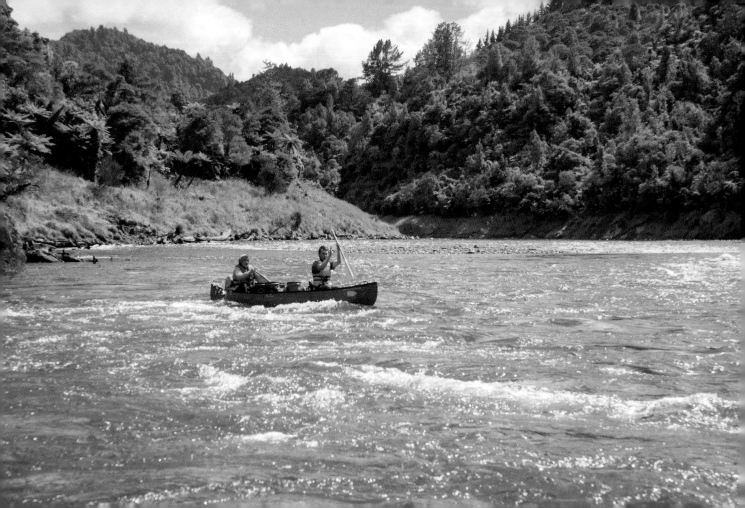

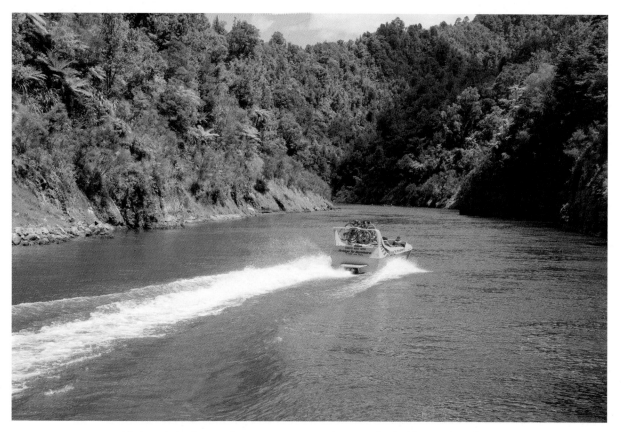

Above: A jet boat takes passengers upriver to the Bridge to Nowhere.
Opposite: Canoeists negotiate the rapids of Whanganui River.

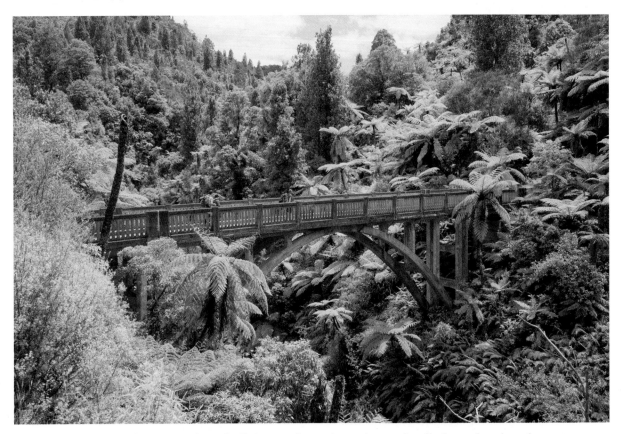

The Bridge to Nowhere, built in 1936 by early settlers and sadly later abandoned.

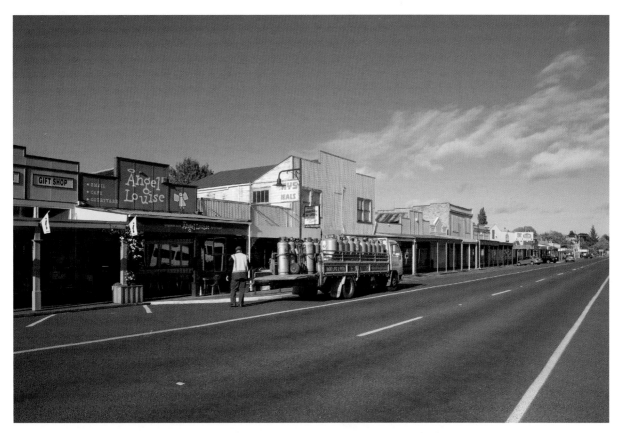

The wide main street of Raetihi, designed to allow for bullock teams to turn.

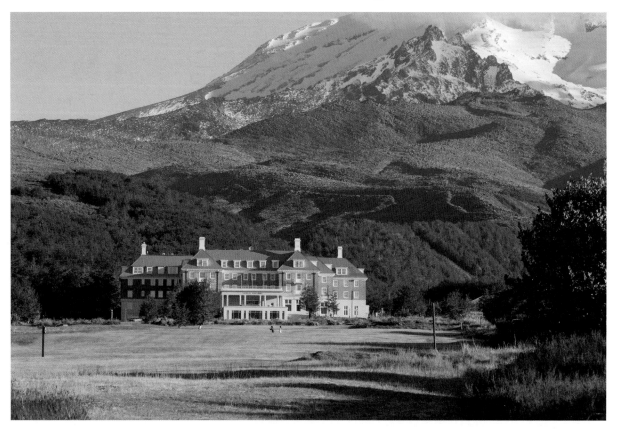

Above: The Chateau Tongariro, built in 1929 in the style of the pre-Depression era.
Opposite: The north-west side of Mt Ruapehu, freshly coated in snow.

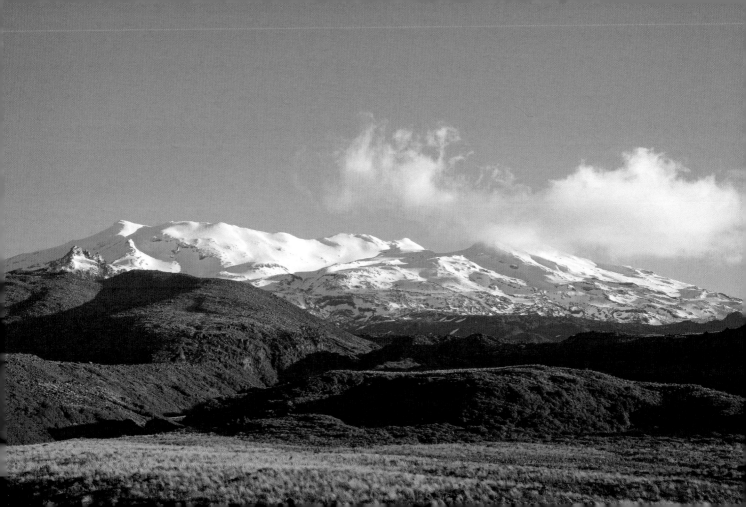

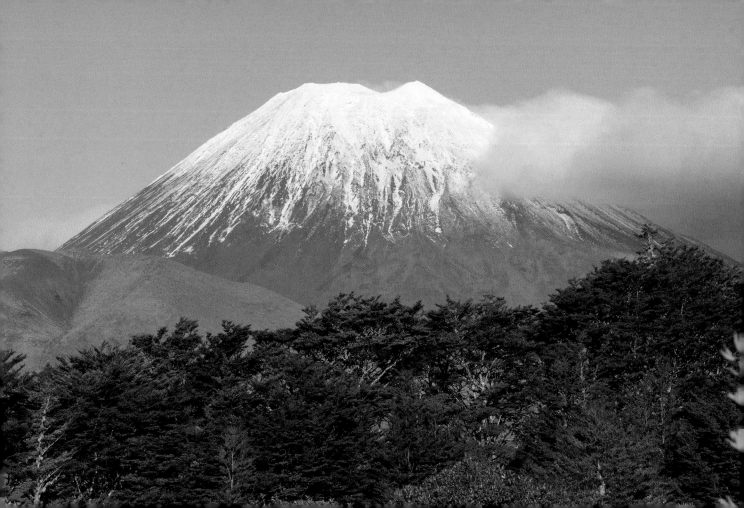

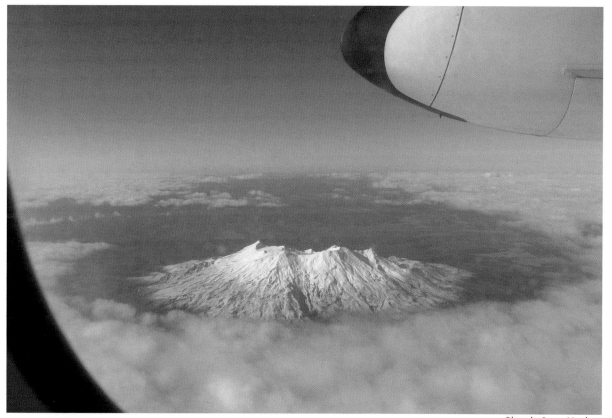

Above: Mt Ruapehu (2,797 m) under winter snow. Opposite: Mt Ngauruhoe (2291 m) is around 2,500 years old and is the youngest of the three volcanoes in the Tongariro National Park.

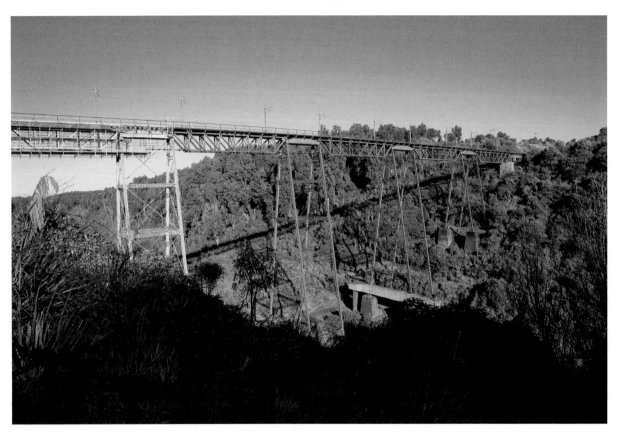

The Makatote railway viaduct, near National Park.

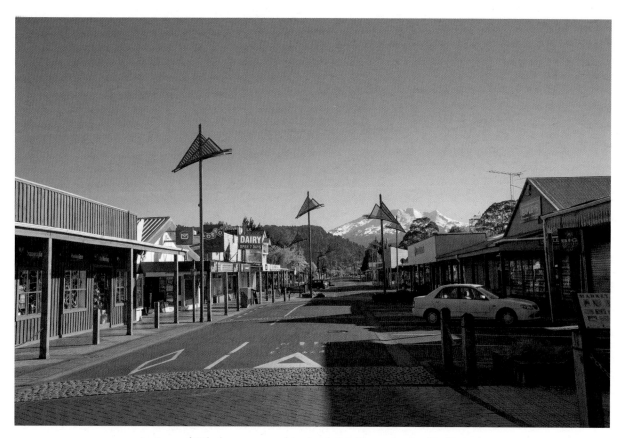

A view of Ohakune township, with Mt Ruapehu in the distance.

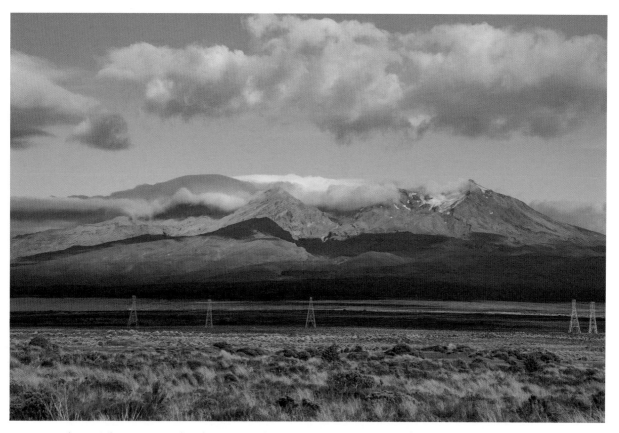

Above: The eastern side of Mt Ruapehu – as seen from State Highway 1 on the desert road.
Opposite: Lush native rainforest – on the road from Ohakune to the Turoa ski field.

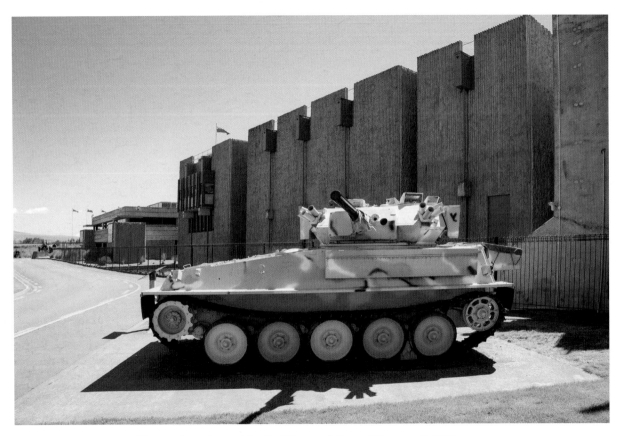

Above: A tank outside the National Army Museum in Waiouru.
Opposite: Fresh spring growth on the trees along State Highway 1 – near Taihape.

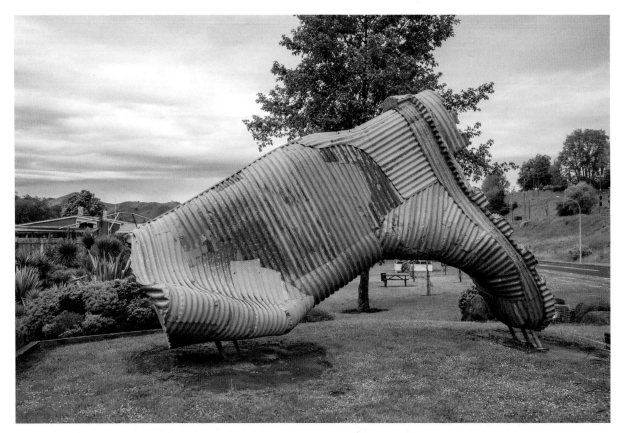

A kiwi icon – the corrugated iron gumboot statue by Jeff Thompson, in Taihape.

The main street of Taihape on State Highway 1.

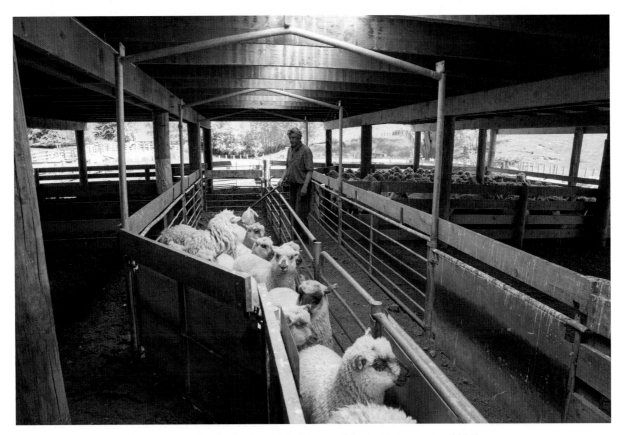

Above: Gary herds the lambs in his woolshed – just south of Taihape.
Opposite: The deep gorges of the Rangitikei River, as seen from the Mokai Bridge.

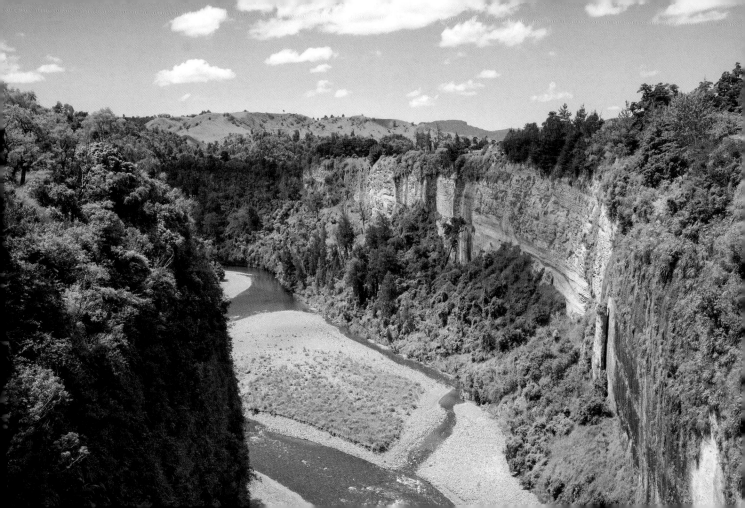

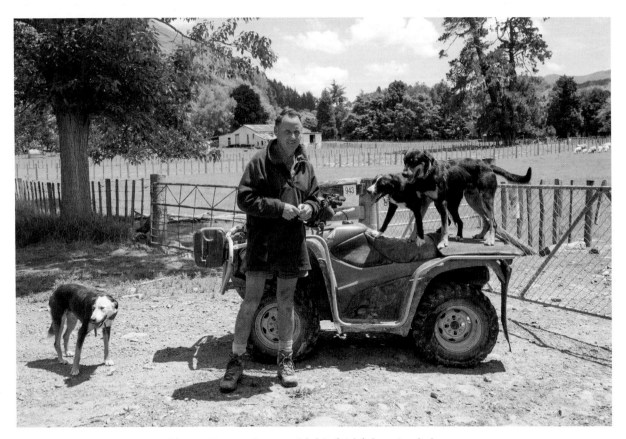

Above: Farmer Stuart with his faithful canine helpers.

Opposite: The Rangitikei River is one of New Zealand's longest rivers, 185 kilometers long.

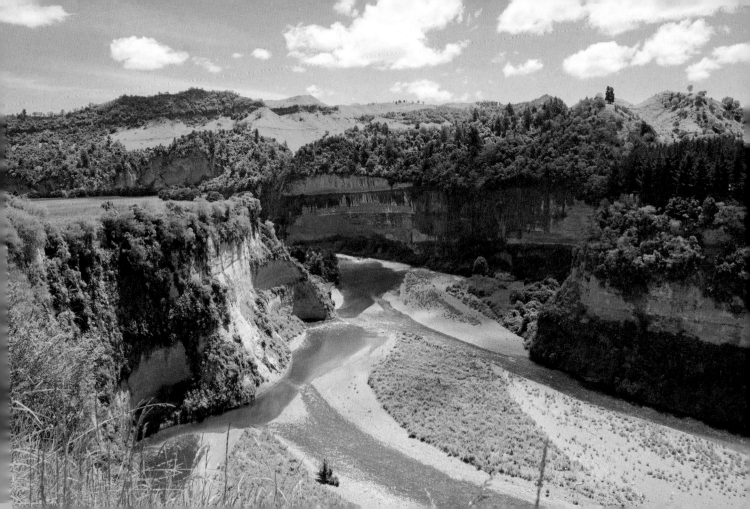

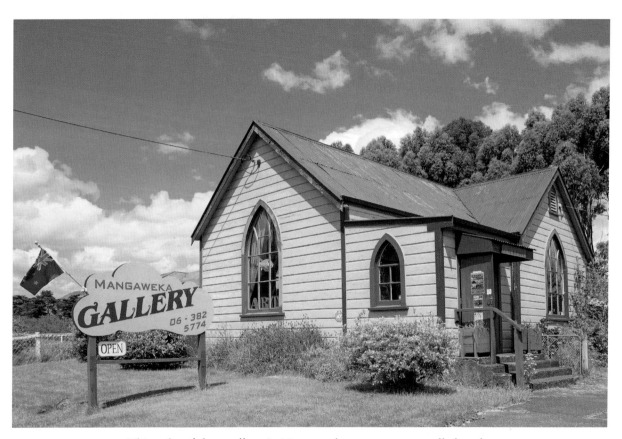
This colourful art gallery in Mangaweka, was once a small church.

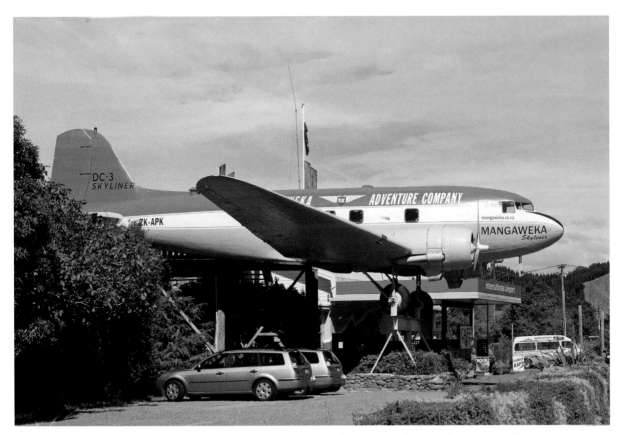

A DC3 Skyliner Mangaweka. The final flight of this DC-3 took place in 1981.

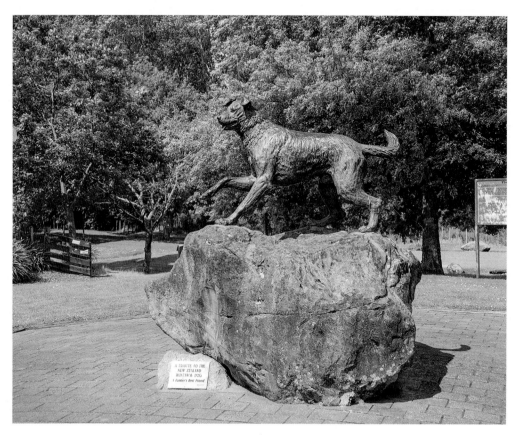

A Farmer's Best Friend – the bronze tribute statue of a huntaway sheepdog in Hunterville.

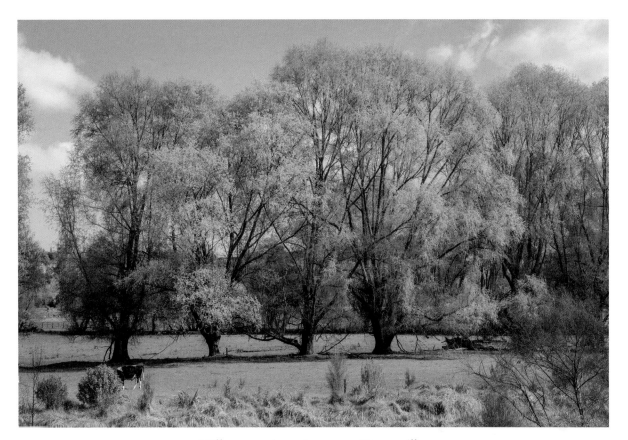

Willow trees in spring – near Hunterville.

Summer skies over farmland near Marton.

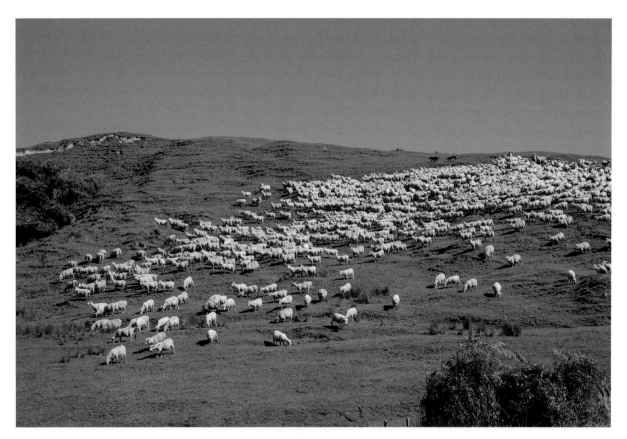

A mob of sheep being herded, seen from State Highway 54.

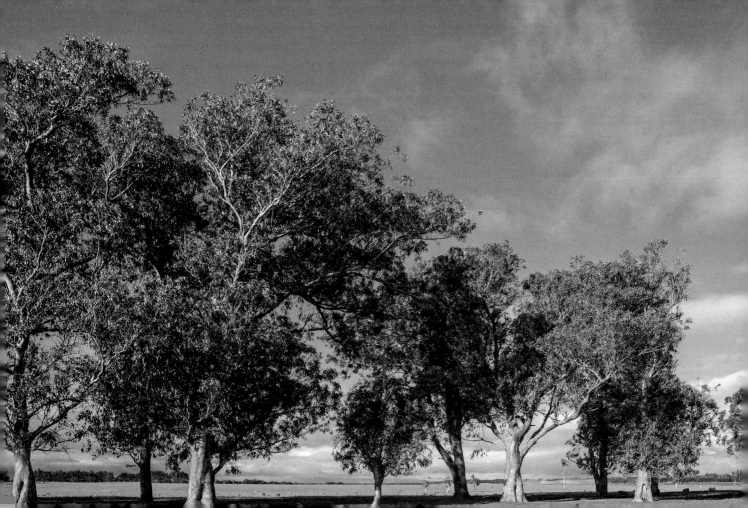

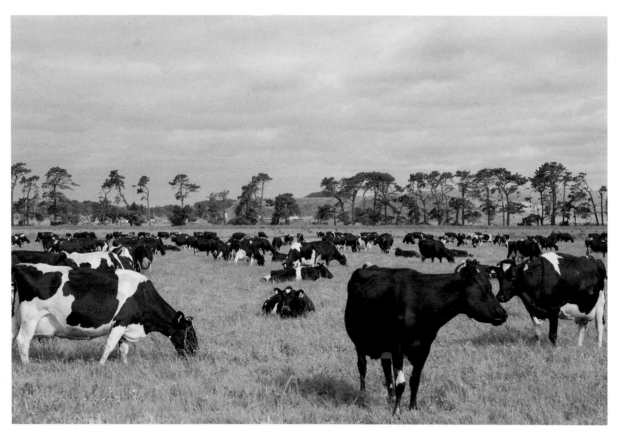

Above: Fresian cows on the roadside – on the way to Koitiata.
Opposite: Gum trees – alongside the highway, between Marton and Bulls.

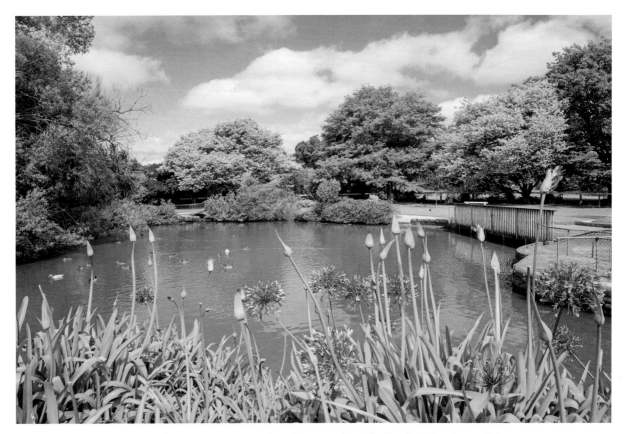

Frae-Ona Park in Marton was privately owned until gifted to the Council in 1962.

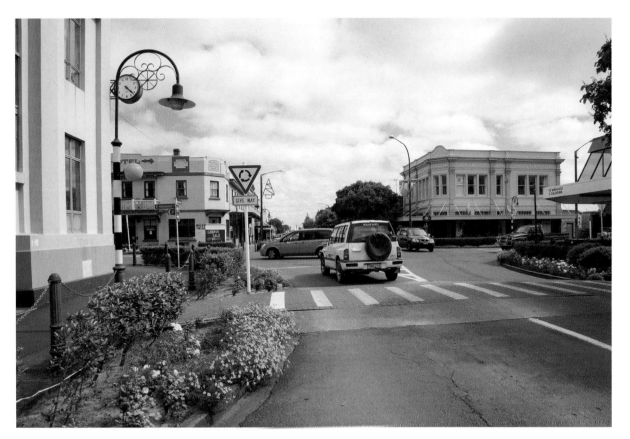

Marton is a small rural town about halfway between Palmerston North and Wanganui.

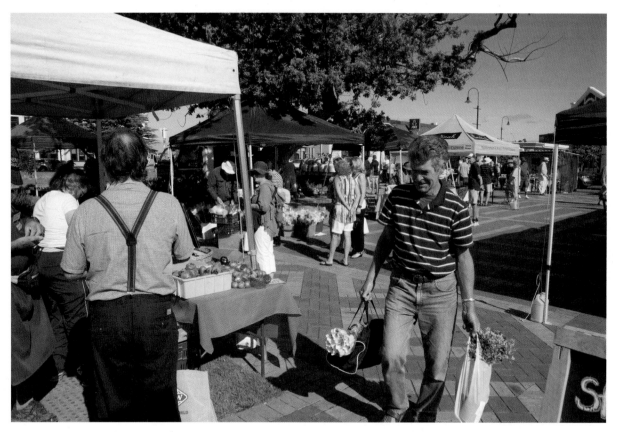

Above: The award-winning Feilding Farmers' Market, brings town and country together.
Opposite: Located in the Feilding town centre, the sale yards attract interest from visitors and farmers.